ICONS

Graphic Design for the 21st Century

Grafikdesign im 21. Jahrhundert
Le design graphique au 21ᵉ siècle

Cover:
Waste Painting # 3
New Order covers, 2002
By Saville, Hetherington, Wakefield

To stay informed about upcoming TASCHEN
titles, please request our magazine at
www.taschen.com/magazine or write to TASCHEN,
Hohenzollernring 53, D–50672 Cologne, Germany,
contact@taschen.com, Fax: +49-221-254919.
We will be happy to send you a free copy of our magazine
which is filled with information about all of our books.

© 2005 TASCHEN GmbH
Hohenzollernring 53, 50672 Köln
www.taschen.com

Editorial coordination: Julia Krumhauer, Cologne
German translation: Annette Wiethüchter, Berlin
French translation: Philippe Safavi, Paris
Production: Martina Ciborowius, Cologne

Printed in Italy
ISBN 978–3–8228–3878–5

Graphic Design for the 21st Century

Grafikdesign im 21. Jahrhundert
Le design graphique au 21ᵉ siècle

Charlotte & Peter Fiell

TASCHEN

HONG KONG KÖLN LONDON LOS ANGELES MADRID PARIS TOKYO

Graphic Design for the 21st Century

Grafikdesign im 21. Jahrhundert

Le design graphique au 21e siècle

Over the last decade graphic design has undergone a momentous change as pixels and software have been substituted for pen and paper. In no other design discipline have computers had such an impact, and this is why Graphic Design for the 21st Century is dedicated to the visions of designers working at today's graphic coalface. The forty-five designers included in this celebration of contemporary graphic design have been selected for their forward-looking work. From the Netherlands and Switzerland to America and Iceland to Japan and Australia, this is a truly international survey revealing a shared passion for visual communication.
Graphic messages surround us. Indeed they have become so integral to modern life – from advertising billboards to logos on clothes – that often we register their codes only subconsciously. Against this ever-present visual backing track, graphic designers vie for the viewer's attention. They can either grab it in a bold and direct manner or reel us in with ambiguity or double-coded meanings. In this sea of information and images the best "snaggers" of attention bait their hooks with meaningful content, quirkily intelligent humour or (more rarely) genuine formal invention. Because of this bombardment of visual imagery, we have not only become more literate in deciphering their intentions, but we have also become jaded by the sameness of much mainstream marketing-led communication. These days, for something to attract our attention it has to be really thought provoking or amusing. Today, more than at any other time, the pressure to produce distinctive work that conveys a message in a captivating way is extreme. And that's not all; graphic design just got bigger. The profession has broadened as the boundaries between creative disciplines have blurred through the

Im letzten Jahrzehnt hat sich im Bereich des Grafikdesigns ein revolutionärer Wandel vollzogen, da digital erzeugte Pixel zum Ersatz für Bleistift und Papier geworden sind. Deshalb widmet sich „Grafikdesign im 21. Jahrhundert" den Visionen der Gestalter, die das Feld der zeitgenössischen Gebrauchsgrafik beackern. Fünfundvierzig Designer – von den Niederlanden, der Schweiz, Island und Amerika bis nach Japan und Australien – werden mit ihren zukunftsweisenden Entwürfen in diesem Band vorgestellt, so dass er ein internationales Abbild des leidenschaftlichen Engagements der Berufsgruppe für visuelle Kommunikation darstellt.
Grafische Informationen – von Werbeplakaten bis zu den Logos auf Kleidungsstücken – sind ein so allgegenwärtiger Teil des modernen Lebens, dass wir ihre Codes schon gar nicht mehr bewusst wahrnehmen. Angesichts der um sich greifenden „Hintergrund-Bild-berieselung" wetteifern die Gebrauchsgrafiker um die Aufmerksamkeit des Publikums, entweder forsch und direkt oder indem sie uns mit doppelt verschlüsselten Botschaften umgarnen.
In dieser Informations- und Bilderflut sind diejenigen am erfolgreichsten, die den Betrachter mit sinnvollen Inhalten, witzigen, geistreichen und/oder – was eher selten ist – echten formalen Neuheiten ködern. Da wir täglich mit visuellen Informationen bombardiert werden, erkennen wir ihre Absichten schneller, sind gegenüber dem stilistischen Einheitsbrei der gängigen marktorientierten Werbung aber auch abgestumpft. Damit etwas heute unsere Aufmerksamkeit länger als nur einige Sekunden lang fesselt, muss es wirklich amüsant sein oder zum Nachdenken anregen. Nie zuvor standen die Grafiker unter größerem Druck als zurzeit, originelle Entwürfe zu liefern, die eine Werbebotschaft auf packende

Au cours de la dernière décennie, les arts graphiques ont connu une formidable révolution, les pixels et les logiciels ayant remplacé le crayon et le papier. Aucune autre discipline du design n'a été autant marquée par l'avènement de l'informatique. C'est pourquoi Le Design graphique au 21e siècle se consacre aux visions des tenants actuels de la profession. Les quarante-cinq graphistes présentés ici ont été choisis tout particulièrement pour leur travail résolument orienté vers l'avenir. Des Pays-Bas à la Suisse, des Etats-unis à l'Islande, du Japon à l'Australie, cet échantillonnage international des arts graphiques témoigne d'une passion partagée pour la communication visuelle.
Nous sommes entourés de messages graphiques. Ils sont désormais tellement intégrés à la vie moderne – des panneaux d'affichage aux logos sur nos vêtements – que, le plus souvent, nous n'enregistrons leurs codes qu'à un niveau subconscient. Sur cette toile de fond omniprésente, les graphistes rivalisent pour attirer notre attention. Ils peuvent la capter d'une manière directe et frappante, ou chercher à nous circonvenir avec une ambiguïté visuelle ou des doubles sens. Dans cet océan d'informations et d'images, ceux qui parviennent le mieux à nous «accrocher» sont ceux qui nous appâtent avec un contenu intelligent, un humour décalé et futé, ou (plus rarement) une véritable inventivité dans la forme. Du fait de ce bombardement d'images, nous avons appris à déchiffrer leurs intentions et sommes revenus de l'aspect répétitif des communications traditionnelles guidées par des «stratégies de marché». De nos jours, pour qu'un message retienne notre attention, il doit vraiment faire réfléchir ou amuser. Plus qu'à n'importe quelle autre époque, les professionnels subis-

application of new democratising digital technologies. For the vast majority of designers in this survey the computer has become their primary tool, but there is also a desire to break out of the limitations imposed by off-the-shelf software programmes. The Internet and advanced computing power have pushed forward graphic design practice, yet at the same time this has also speeded the stylistic obsolescence of design solutions – what appears cutting-edge one year will seem old hat the next. In the last ten years graphic design has grown from a primarily static medium of encapsulated messages (books, posters, display ads, etc.) to one increasingly about movement and play and which is open to interaction through screen-based so-called graphic user interfaces (GUIs). This does not mean, however, that we should prepare obituaries for the printed page as new computer technologies have actually made book design easier – hence the proliferation of small print-run publications showcasing the work of individual graphic designers. Indeed, this type of publication, along with the journals, exhibitions and award ceremonies dedicated to graphic design, help to promote this omnipresent yet often invisible profession, while also facilitating the cross-pollination of ideas amongst practitioners. The Internet has also revolutionised the transference of ideas between graphic designers instigating unprecedented collaboration between design communities around the world. It is, however, printed publications such as this one that not only tangibly demonstrate the flux of graphic design, but which may remain the best record of work as new media platforms perpetually render other not-so-new ones obsolete. In comparison to print, New Media is in its infancy and today's generation of graphic designers are still experimenting with its communicative potential. The evolution of graphic design has been, and will remain, inextricably linked to the technological tools that enable designers to

Weise transportieren. Und das ist noch nicht alles: Die Welt der Gebrauchsgrafik ist in dem Maße größer geworden, in dem sich die Grenzen zwischen den verschiedenen gestalterischen Berufen verwischt haben, und zwar durch die Nutzung der allseits verfügbaren modernen digitalen Technik. Die meisten der hier vorgestellten Grafiker nutzen den Computer als Hauptarbeitsmittel. Dennoch verspüren viele den Wunsch, die ihnen von den handelsüblichen Softwareprogrammen aufgezwungenen Grenzen zu überschreiten. Das Internet und höhere Rechnerleistungen haben die Entwurfsarbeit zwar beschleunigt, lassen grafische Lösungen und Stilmerkmale aber auch schneller veralten: Was dieses Jahr hochmodern erscheint, ist schon nächstes Jahr ein alter Hut. In den letzten zehn Jahren hat sich das Grafikdesign von einem überwiegend statischen Medium mit fixierten Botschaften (Bücher, Anzeigen, Plakate) zu einem Medium entwickelt, bei dem es zunehmend um Bewegung und Spiel geht und das am Bildschirm über Benutzeroberflächen (graphic user interfaces GUIs) zur Interaktion einlädt. Das heißt nicht, dass wir nun Nachrufe auf das gedruckte Wort schreiben sollten, denn neue Computertechniken haben ja gerade die Herstellung von Büchern erleichtert. Dies hatte eine wachsende Zahl von Publikationen in kleinen Auflagen zur Folge, mit denen sich einzelne Grafiker profilierten. Tatsächlich tragen diese Publikationen neben zahlreichen einschlägigen Fachzeitschriften, Ausstellungen und Grafikpreisen dazu bei, das Profil dieser allgegenwärtigen, oft jedoch unsichtbar und anonym wirkenden Berufsgruppe zu schärfen und zugleich die wechselseitige Anregung ihrer einzelnen Mitglieder untereinander zu fördern. Das Internet hat den Gedanken- und Erfahrungsaustausch unter Grafikern entscheidend vorangetrieben und dazu beigetragen, Kooperationen rund um den Globus in noch nie dagewesenem Ausmaß zu schaffen. Es sind allerdings Drucker-

sent une pression énorme pour produire un message original et captivant. Mais ce n'est pas tout, l'importance du graphisme n'a cessé de croître. Le secteur s'est élargi à mesure que les nouvelles technologies numériques ont démocratisé les disciplines créatives en rendant de plus en plus floues les frontières qui les séparaient autrefois. L'ordinateur est devenu l'outil principal de la grande majorité des graphistes présentés ici, même si beaucoup d'entre eux souhaiteraient se libérer des contraintes imposées par les logiciels disponibles dans le commerce. L'Internet et la puissance informatique ont favorisé le développement du secteur mais également accéléré le processus d'obsolescence des solutions graphiques : ce qui paraît révolutionnaire aujourd'hui sera totalement dépassé demain. Au cours de la dernière décennie, le graphisme est passé d'un média essentiellement statique servant à transmettre des messages fixes (livres, affiches, publicités, etc.) à un outil mobile et ludique, ouvert à l'interaction depuis l'avènement des IUG («Interfaces Utilisateurs Graphiques») sur écran d'ordinateur. Cela ne signifie pas pour autant la mort de la page imprimée : les nouvelles technologies informatiques ont facilité la réalisation de livres, entraînant également la prolifération de petites publications sur papier présentant le travail de graphistes indépendants. De fait, ce genre de brochures, tout comme les nombreuses revues, expositions et remises de prix consacrés aux arts graphiques contribuent à promouvoir cette profession omniprésente mais souvent invisible, tout en facilitant la pollinisation croisée des idées parmi ses praticiens. L'Internet a également révolutionné la transmission des idées entre graphistes et favorisé un degré de collaboration sans précédent entre différentes communautés de professionnels à travers le monde. Toutefois, ce sont des ouvrages imprimés tels que celui-ci qui, non seulement exposent de manière tangible les courants actuels des

work with ever-greater efficiency. Apart from illustrating the current output of forty-five leading graphic designers, this survey also includes "in-their-own-words" what they think the future of graphic design will hold. And beyond featuring some of the most interesting contemporary work, this book attempts to predict the future of graphic design in relation to its convergence with other disciplines, its continuing love affair with technology, its complicity with corporate globalisation and its adoption of the ambiguity of Post-Modern cultural interpretation over the clarity of Modern universal communication. In an attempt to determine where graphic design might be heading, we have identified the common concerns of the selected designers. These are: the blurring of disciplinary boundaries; the importance of content; the impact of technology; the desire for emotional connections; the constraints imposed by commercial software; the distrust of commercialism; the increasing quantity and complexity of information; the need for simplification; and the necessity of ethical relevance. In the early1990s Post-Modernism escaped from the confines of design institutions, music and art scenes and was embraced by corporate marketeers searching for the elusive elixir of cool. The gulf between progressive educational theory and mainstream professional practice appeared to have been bridged. There was, however, a growing realisation among a new generation of Late Modern designers – many of whom are included in this survey – that style and content are equally important in Good Design solutions (a very un-PoMo notion). Today's New Pluralism in graphic design must be seen as a response to the greater multiculturalism of today's global society and as an indication of the strong desire of designers to develop their own unique style. Many designers are challenging traditional notions of beauty with provocative work expressing radical ideas. The major-

zeugnisse wie das vorliegende Buch, die den kulturellen Fluss des zeitgenössischen Grafikdesigns nicht nur in Texten und Bildern belegen, sondern auf Dauer auch die zugänglichste Informationsquelle aus bunten Rasterpunkten bleiben werden, da ständig neue Internetportale die älteren überflüssig machen. Im Vergleich zum gedruckten Wort und Bild stecken die „neuen Medien" noch in den Kinderschuhen und die zeitgenössischen Pioniere der Computergrafik sind noch damit beschäftigt, deren kommunikatives Potenzial zu erschließen. Die Entwicklung des Grafikdesigns wird auch weiterhin von der Entwicklung der dafür notwendigen Technologie abhängig sein, die es den Grafikern erlaubt, immer effizienter zu arbeiten.
Das vorliegende Buch illustriert nicht nur das aktuelle Schaffen von 45 führenden Grafikdesignern, sondern enthält auch deren Selbstdarstellungen und Auskunft darüber, wie sie die Zukunft des Grafikdesigns sehen. In diesem Überblick findet der Leser nicht nur Abbildungen einiger der interessantesten Arbeiten aus jüngster Zeit, sondern auch fundierte Prognosen über die Zukunft des Gewerbes in Bezug auf seine Verflechtung mit anderen Fachdisziplinen, seine enge Beziehung zu modernster Technik, seine Komplizenschaft mit der wirtschaftlichen Globalisierung und die Tatsache, dass Grafiker heute vielfach der poetischen Vieldeutigkeit postmoderner kultureller Interpretationen den Vorzug vor der universellen Klarheit der Moderne geben. Im Bemühen um eine Prognose über den Weg, den das Grafikdesign einschlagen wird, haben wir zunächst bei den hier ausgewählten Vertretern des Fachs eine Reihe gemeinsamer Nenner identifiziert: den Wunsch nach Aufhebung fachlicher Schubladendenkens, die vorrangige Bedeutung von Inhalten, den Einfluss der Technologie auf ihre Arbeiten, den Wunsch nach emotionalen Assoziationen und nach Überwindung der von den handelsüblichen Softwareprogrammen gezogenen Grenzen, das

arts graphiques, mais demeureront sans doute l'archive la plus accessible tandis que de nouvelles plates-formes médiatiques rendront perpétuellement obsolètes celles qui les ont précédées. Comparés à l'imprimerie, les médias numériques n'en sont qu'à leurs premiers balbutiements et la génération actuelle de graphistes en est encore à expérimenter leur potentiel communicatif. L'évolution des arts graphiques a toujours été et restera inextricablement liée aux outils technologiques qui permettront aux graphistes de travailler avec une efficacité sans cesse accrue.
Cet ouvrage ne se contente pas de présenter le travail actuel de quarante-cinq graphistes de premier plan mais leur permet également d'expliquer avec leurs propres termes comment ils envisagent l'avenir du secteur. Outre le fait de présenter certaines des créations graphiques les plus intéressantes du moment, ce livre émet des prédictions sur l'évolution du design graphique à la lumière de ses liens avec d'autres disciplines, de sa longue histoire d'amour avec la technologie de pointe, de sa complicité avec la mondialisation et de sa préférence pour l'ambiguïté poétique de l'interprétation culturelle postmoderne plutôt que pour la clarté de la communication universelle moderniste. Dans notre étude des orientations futures du graphisme, nous avons identifié les préoccupations communes des graphistes sélectionnés : l'effacement des frontières entre les disciplines ; l'importance du contenu ; l'impact de la technologie ; l'envie d'établir des liens émotionnels ; les contraintes créatives imposées par les logiciels du commerce ; la méfiance à l'égard du mercantilisme ; la quantité, la complexité et l'accélération croissante de l'information ; le besoin de simplification ; la nécessité d'une déontologie pertinente.
Au début des années quatre-vingt dix, le postmodernisme sort des confins des institutions du design, de la musique et de l'art pour être

ity of today's image-makers have been inspired by art and film and have incorporated aspects of these disciplines into their work, leading in turn to a broader interpretation of what constitutes graphic design. Designers such as M/M and Jonathan Barnbrook have developed close associations with the art world, however, their work generally remains constrained by the client's brief and as such cannot match the creative freedom of art. Increasingly designers are therefore subsidizing self-initiated experimental work that allows them to express their creative individuality with revenues from well-paid commercial work. Many have realised that uncertain meaning can evoke a sense of mystery, capturing and holding the viewer's attention. This phenomenon has led graphic design to be used not to solve a communication problem, but as a way of posing a riddle. There are also, however, a growing number of designers producing more text-based work, with a single powerfully direct message. Often this directness comes about because the communicator stands for an ideal and promotes his/her cause with the utmost clarity. Since the early 1990s "Subvertising" with its jamming of corporate messages has displayed a communicative directness in its attempt to spearhead an anti-globalisation revolution. Certainly there is now a growing realisation that simplification is often the best way to filter information from an ocean of trivia, and that in the future graphic designers may become "information architects" creating tools to help the user navigate the currents of the digital age. The complicity of the graphic design profession with big business has contributed to the expansion and globalisation of commercial culture and perhaps practitioners should now question the ethical basis of their work. For too long graphic design has been cynically used to induce the developed world to buy more products it doesn't really need, while in developing nations millions lack the basic necessities

Misstrauen gegenüber dem Kommerz, die zunehmende Menge und Komplexität der Informationsflüsse, die Notwendigkeit der Vereinfachung und die Notwendigkeit ethisch vertretbarer Entwürfe. Anfang der 1990er Jahre war die Postmoderne aus den Beschränkungen der Designinstitutionen, der Musik- und Kunstszene ausgebrochen und eroberte die Welt der Marketingfachleute, die verzweifelt auf der Suche nach dem schwer zu fassenden, als „cool" bezeichneten Elixier und Herzblut der Markenbildung waren. Die Kluft zwischen progressiver Bildungstheorie und gängiger Berufspraxis schien überwunden. Allerdings machte sich unter den jüngeren Grafikern der Spätmoderne – von denen viele in diesem Buch vertreten sind – die (ganz und gar nicht postmoderne) Erkenntnis breit, dass Stil und Inhalt für gute Designlösungen gleichermaßen erforderlich sind. Der aktuell herrschende neue Pluralismus im Grafikdesign muss einerseits als Folge der größeren Multikulturalität unserer Weltgemeinschaft gesehen werden und andererseits als Ergebnis des ausgeprägten Bemühens vieler Designer um ihren ureigenen Stil. Viele Grafiker stellen die herkömmlichen Schönheitsbegriffe in Frage, und zwar mittels provokanter Arbeiten, in denen sie radikale Konzepte ausdrücken. Die meisten heute tätigen Bildermacher lassen sich von Kunst und Film inspirieren und verarbeiten diese Anregungen, was dazu geführt hat, dass der Begriff Grafikdesign derzeit weiter gefasst und interpretiert wird als früher. Designer wie M/M und Jonathan Barnbrook pflegen enge Beziehungen zur Kunstszene. Ein Großteil ihrer Arbeitsleistung ist jedoch den Vorgaben der Kunden unterworfen und sie können daher niemals die völlige schöpferische Freiheit des bildenden Künstlers erlangen. Daher subventionieren Grafikdesigner in zunehmendem Maße eigene experimentelle Initiativen aus den Erlösen gut bezahlter Aufträge aus der Wirtschaft. Diese Projekte erlauben es ihnen, künstlerische Indi-

largement récupéré par les départements de marketing dans leur quête effrénée de l'élixir volatil du «cool». Le gouffre entre la théorie pédagogique progressiste et la pratique professionnelle au sens large semblait avoir été comblé. Toutefois, la nouvelle génération de graphistes appartenant au «modernisme tardif», dont bon nombre figurent dans cet ouvrage, prit peu à peu conscience du fait que style et contenu étaient aussi importants l'un que l'autre dans la création de solutions pour un «Bon Design» (une notion très éloignée du postmodernisme). Le nouveau pluralisme d'aujourd'hui doit s'interpréter comme une réaction au multiculturalisme accru de notre société planétaire et le signe d'un puissant désir des graphistes de développer un style qui leur soit propre. Bon nombre d'entre eux remettent en question les critères traditionnels de beauté en réalisant des projets provocants qui expriment des idées radicales. La majorité de ceux qui fabriquent des images aujourd'hui ont été inspirés par l'art et le cinéma dont ils ont intégré des aspects dans leurs travaux, ce qui, en retour, a élargi l'interprétation de ce qu'on entend par graphisme. Des graphistes tels que M/M et Jonathan Barnbrook ont tissé des liens étroits avec le monde de l'art. Toutefois, leur travail demeure assujetti au projet de leur client et, à ce titre, ne peut prétendre à la liberté créative de l'art. C'est pourquoi ils sont de plus en plus nombreux à financer leurs propres recherches expérimentales avec les revenus de commandes commerciales bien rémunérées. Beaucoup ont compris que l'ambiguïté peut créer une impression de mystère, captant et retenant ainsi l'attention du spectateur. De par ce phénomène, le graphisme est souvent utilisé non plus pour résoudre des problèmes de communication mais pour soumettre des énigmes au public. On remarque également un nombre croissant de graphistes produisant des travaux qui reposent davantage sur le texte, avec un message direct, unique et puissant. Ce côté

of life. To make matters worse these superfluous products are often made in sweatshops by the most deprived members of our global society, yet all too frequently graphic designers help corporations gloss over such brand-depreciating details. Rather than selling questionable products, graphic designers could use their ingenuity to highlight social and environmental concerns. In fact this is already happening at a grassroots level, as can be gleaned from a perusal of Adbusters magazine.

Above all, graphic designers should acknowledge that they have a responsibility (and ability to respond) not just to the needs of their clients but also to those of society. The persuasive power of graphic design could radically alter the way people think about the issues of the future, from global warming to third world debt. Although not all the work done by graphic designers falls into the realm of ethical decision-making, the profession still needs to tip the balance from the commercial to the social to remain a relevant and vital cultural force.

Please note: for the purpose of this essay we are viewing graphic design in terms of the combination of text and image. Typography as a specialisation of graphic design has of course, a much longer history.

vidualität zu entwickeln und eigene Ideen umzusetzen. Viele haben erkannt, dass mehrdeutige Inhalte etwas Geheimnisvolles haben, das die Aufmerksamkeit des Betrachters auf sich zieht und fesselt. Aufgrund dieses Phänomens werden grafische Entwürfe nicht länger als Mittel zur Lösung einer Kommunikationsaufgabe gesehen, sondern als Chance, ein Kommunikationsrätsel zu formulieren. Andererseits gibt es eine wachsende Anzahl von Grafikern, die stärker auf Text basierende Arbeiten mit einer einzigen, eindrucksvoll direkten Botschaft entwickeln. Die Unmittelbarkeit entsteht in diesen Fällen, weil der Mitteilende ein Idealist ist, der seinen „Fall" mit äußerster Deutlichkeit und Klarheit vorbringen will. Seit Anfang der 1990er Jahre hat die Praxis des „Subvertising" (subverting and advertising = Subversion und Werbung) mit ihrer Verballhornung von Firmenwerbung – in dem Versuch der Konterrevolution gegen die Globalisierung – einen ausgeprägt direkten Kommunikationsstil an den Tag gelegt. Auf jeden Fall wächst heute die Erkenntnis, dass Vereinfachung in vielen Fällen die beste Methode ist, um wichtige Informationen aus einer endlosen Flut von Trivialitäten herauszufiltern, und dass Grafiker in Zukunft die Pflicht haben, sich zu „Informationsarchitekten" auszubilden, damit sie Werkzeuge schaffen können, die dem Benutzer dabei helfen, die vielfältigen Klippen des Computerzeitalters zu umschiffen.

Die lange währende Allianz der Gebrauchsgrafiker mit dem Big Business hatte die rasche Expansion und Internationalisierung der Konsum- und Werbekultur zur Folge und es ist daher vielleicht für die in diesem Bereich arbeitenden kreativen Köpfe an der Zeit, die ethischen Grundlagen ihrer Arbeit zu überprüfen. Allzu lange ist die grafische Kunst auf zynische Weise dazu missbraucht worden, die Menschen in den hoch entwickelten Ländern zum Kauf von Produkten zu verleiten, die sie nicht wirklich brauchen, während Millionen in den unterentwickelten Ländern

«droit au but» vient souvent de ce que l'annonceur incarne un idéal et veut promouvoir sa cause avec la plus grande clarté possible. Depuis le début des années quatre-vingt-dix, le «Subvertising» (mélange de «subversion» et de «publicité»), avec son carambolage de messages commerciaux, fait preuve d'une grande efficacité communicative dans sa tentative d'être le fer de lance de la révolution anti-mondialiste. En effet, on paraît aujourd'hui de plus en plus convaincu que la simplification est souvent le meilleur moyen de filtrer l'information dans un océan sans fond de futilités. A l'avenir, les graphistes pourraient devenir des «architectes de l'information», créant des outils qui aideront l'utilisateur à mieux naviguer sur les courants complexes du numérique. La complicité entre le métier de graphiste et les grandes entreprises a conduit à l'expansion et à la mondialisation d'une culture commerciale. Il est peut-être temps pour ces professionnels de s'interroger sur les fondements éthiques de leur travail. Le graphisme a été trop longtemps utilisé cyniquement pour inciter les pays industrialisés à consomer plus que ce dont ils avaient besoin alors que, dans les pays en voie de développement, des millions de gens manquent de tout. Pour ne rien arranger, ces produits superflus sont souvent fabriqués dans des ateliers clandestins par les membres les plus démunis de notre société planétaire. Les graphistes ont trop souvent aidé les entreprises à mettre leurs marques en valeur, en effaçant ces détails dérangeants. Plutôt que de vendre des produits discutables, ils pourraient mettre leur sens aigu de la communication au service de préoccupations sociales et écologiques. De fait, c'est ce qui se passe déjà au travers de mouvements populaires comme on peut le constater en feuilletant le magazine Adbusters.

Avant tout, les graphistes devraient reconnaître leur responsabilité particulière (et leur capacité à y faire face) non seulement vis-à-vis de

noch nicht einmal das Notwendig-
ste zum Leben haben. Die Situation
wird noch dadurch verschlimmert,
dass diese überflüssigen Artikel
häufig in elenden Werkstätten von
den ärmsten Mitgliedern der globa-
len Gesellschaft zu Hungerlöhnen
hergestellt werden. Allzu oft haben
Werbegrafiker den westlichen Fir-
men noch geholfen, derartige
„markenschädigende" Fakten mit-
tels Hochglanz-Werbekampagnen
zu vertuschen. Anstatt Beihilfe zum
Absatz fragwürdiger Produkte zu
leisten, könnten Grafiker ihr kom-
munikatives Talent dazu benutzen,
lebenswichtige soziale und ökologi-
sche Belange ans Licht der Öffent-
lichkeit zu bringen. Tatsächlich pas-
siert das schon jetzt – und zwar an
der Basis –, wie man schon beim
flüchtigen Durchblättern der Zeit-
schrift Adbusters (Anzeigenspren-
ger) bemerkt.

Vor allem aber müssen Grafiker er-
kennen, dass sie eine besondere
Verantwortung dafür tragen (und
auch dazu fähig sind), nicht nur die
Bedürfnisse ihrer Auftraggeber zu
erfüllen, sondern auch die der Ge-
sellschaft als Ganzes. Die Überzeu-
gungskraft der Gebrauchsgrafik
könnte so mobilisiert und einge-
setzt worden, dass sie eine radikale
Umkehr im Denken der Menschen
über wichtige Zukunftsfragen her-
beiführt – von der Erwärmung der
Erdatmosphäre bis zu den Schul-
denbergen der Entwicklungsländer.
Obwohl nicht alle Arbeiten den Be-
reich ethischer Entscheidungsfin-
dungen berühren, müssen Grafik-
designer noch den Schritt vom
überwiegend kommerziellen zum
überwiegend sozialen Engagement
vollziehen, wenn sie eine relevante
und lebendige kulturtreibende Kraft
bleiben wollen.

*Anmerkung: In diesem Essay beschreiben
die Begriffe Gebrauchsgrafik oder Grafikde-
sign die Zusammenstellung von Text und
Bild. Die Typografie als spezielle Form der
Gebrauchsgrafik blickt natürlich auf eine viel
längere Geschichte zurück.*

leurs clients mais aussi de la socié-
té dans son ensemble. La force de
conviction du graphisme pourrait
radicalement modifier la façon dont
nous réfléchissons aux questions
importantes de l'avenir, du réchauf-
fement de la planète à la dette du
Tiers-Monde. Bien que tous les tra-
vaux de graphistes ne relèvent pas
du domaine de la prise de décision
éthique, la profession devra faire
pencher la balance du côté du
social plutôt que de celui du com-
mercial si elle veut rester une force
culturelle pertinente et vitale.

*Note: Dans cet essai, nous examinons le
graphisme comme une combinaison de
textes et d'images. Naturellement, l'histoire
de la typographie en tant que spécialité des
arts graphiques est beaucoup plus longue.*

Aboud Sodano

Aboud Sodano Studio 26, Pall Mall Deposit, 124–128 Barlby Road, London W10 6BL, UK
T +44 20 8968 6142 F +44 20 8968 6143 E mail@aboud-sodano.com www.aboud-sodano.com

"It's only a job, but a good job."

"I really don't think that my vision of the future of graphic design is that relevant or indeed important. Every aspiring designer should stick to his or her beliefs. What I do care about in my work is that it is original, appropriate, and never patronising. My long-term goal is to achieve a healthy and equal balance between design that works strategically but doesn't pollute the environment, and design that creatively pushes boundaries, whether they be aesthetic or about choice of medium. I would ideally like to use the skills that I have as a designer to take on board some social responsibility, as I am actually aware that it is designers of my generation and the one previous that are responsible for the saturation of the High Street with ubiquitous and meaningless design."

» Ich glaube wirklich nicht, dass meine Vision des Grafikdesigns der Zukunft so relevant oder gar bedeutungsvoll ist. Alle aufstrebenden Grafiker und Grafikerinnen sollten ihren Überzeugungen treu bleiben. Mir ist bei meinen Arbeiten wichtig, dass sie originell und passend sind und niemals gönnerhaft wirken. Langfristig verfolge ich das Ziel, eine gesunde Ausgewogenheit zwischen strategisch wirksamen – dabei aber nicht zur Umweltverschmutzung beitragenden – Entwürfen und einem Design herzustellen, das kreativ Grenzen überschreitet, egal ob diese im Bereich von Stil und Ästhetik liegen oder in der Wahl des Mediums. Am liebsten würde ich meine Fähigkeiten und mein erworbenes Wissen als Grafiker dafür einsetzen, soziale Verantwortung zu übernehmen, weil mir bewusst ist, dass die Designer meiner Generation und der Generation meiner Eltern für die allgegenwärtige, sinnlose Grafik unserer Einkaufsstraßen verantwortlich sind.«

« Je ne pense pas que ma vision de l'avenir de la création graphique soit pertinente ni ait la moindre importance. Tout aspirant graphiste devrait s'en tenir à ce qu'il croit. Ce qui m'importe dans mon travail, c'est qu'il soit original, approprié et jamais condescendant. Mon objectif à long terme est de parvenir à un équilibre sain entre un graphisme stratégiquement efficace mais respectueux de l'environnement et un stylisme qui repousse de manière créative les frontières tant esthétiques que celles liées au choix du média. Dans l'idéal, j'aimerais me servir de mon savoir-faire pour assumer une forme de responsabilité sociale, car je me rends compte que les graphistes de ma génération et de celle qui nous a précédés ont saturé les rues de nos villes d'images omniprésentes et insignifiantes.»

Opposite page:

Project
Paul Smith Spring Summer 2002
advertising print campaign.
Photography: Sandro Sodano

Title
Irreverence

Client
Paul Smith Limited, London

Year
2002

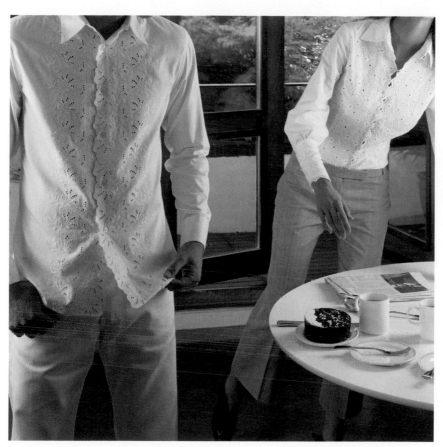

PAUL SMITH

WESTBOURNE HOUSE, 122 KENSINGTON PARK ROAD, LONDON W11 ·
120 KENSINGTON PARK ROAD, LONDON W11 · 40-43 FLORAL STREET,
LONDON WC2 · 84-86 SLOANE AVENUE, LONDON SW3 · 7 THE COURTYARD,
THE ROYAL EXCHANGE, CORNHILL, LONDON EC3 · 22 BOULEVARD RASPAIL,
75007 PARIS · 108 FIFTH AVENUE, NEW YORK, NY 10011 · PALAZZO
GALLARATI SCOTTI, VIA MANZONI 30, 20121 MILANO · www.paulsmith.co.uk

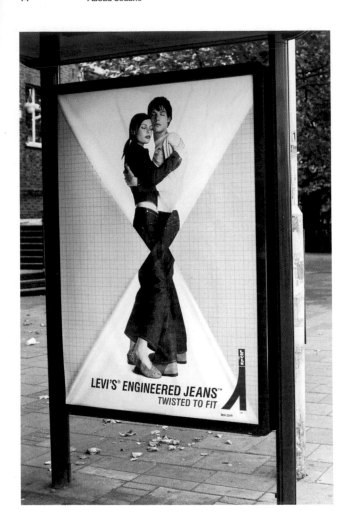

Opposite page:

Project
Levi's Engineered Jeans outdoor print
campaign
Photography: Rankin

Title
Twisted to fit

Client
Bartle Bogle Hegarty, London

Year
2000

Project
Paul Smith Autumn Winter 2002 advertis-
ing print campaign.
Photography: Sandro Sodano

Title
Opposites

Client
Paul Smith Limited, London

Year
2002

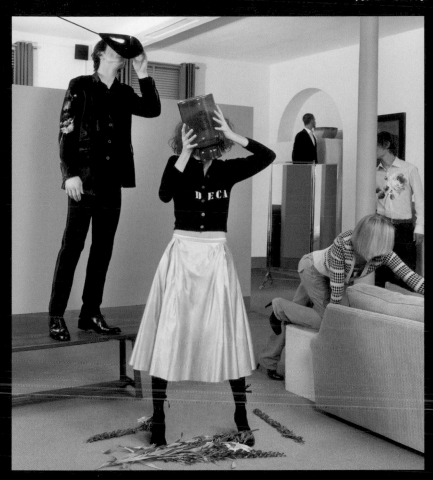

Peter Anderson

Peter Anderson (@ Interfield Design) 2nd Floor, 21 Denmark Street, London WC2H 8NA, UK
T +44 20 7836 5455 F +44 20 7836 2112 E Pete@interfield.freeserve.co.uk www.interfield-design.com

"Graphic design should evolve and challenge existing systems of language and perception."

"Graphic design can control language and also shape our visual urban environment. It is for this reason that I believe we should not allow it to be thrown together in its conceptual construction. Technology has forced changes that many designers and clients have not yet grasped. We have been released from designing solely in blocks and grids, we can embrace the fluid and the organic. We should communicate in an advanced and ever evolving manner, not using quick one-line sellers, not cute, not retro, not post post-modern but real, practically applied and above all, new. We can and should change the way we see the everyday world."

» Grafische Entwürfe sind in der Lage, unsere Sprache zu beherrschen und unsere sichtbare städtische Umwelt zu formen. Deshalb sollten wir nicht zulassen, dass beides beim konzeptionellen Aufbau vermengt wird. Die technische Entwicklung hat uns Veränderungen aufgezwungen, die vielen Grafikern und ihren Auftraggebern noch gar nicht klar sind. Wir sind davon befreit worden, nur in festen Blöcken und Rastern zu denken, wir können uns dem Fließenden und Organischen zuwenden. Wir sollten auf eine fortschrittliche, sich weiterentwickelnde Weise kommunizieren und reale, praktisch anwendbare und vor allem neue Designs liefern. Wir können und sollten unsere Betrachtungsweise der Alltagswelt ändern.«

« Le graphisme peut contrôler le langage et façonner notre environnement visuel urbain. C'est pourquoi nous ne devrions pas le laisser être amalgamé avec sa construction conceptuelle. La technologie a imposé des changements que les graphistes et leurs clients n'ont pas encore eu le temps d'assimiler. Nous avons été libérés des contraintes des blocs et des quadrillages et pouvons désormais travailler dans le fluide, l'organique. Nous devrions communiquer d'une manière pointue, en évolution permanente, sans recourir aux petites phrases accrocheuses, au mignon, au rétro, au post postmoderne mais avec du vrai, du pratique et, surtout, du neuf. Nous pouvons et devrions changer la façon dont nous voyons le monde de tous les jours. »

Opposite page:

Project
World touring exhibition "Ultravision"

Title
"Transglobal numerals"
Northern Ireland series 1

Client
The British Council

Year
2000–2001

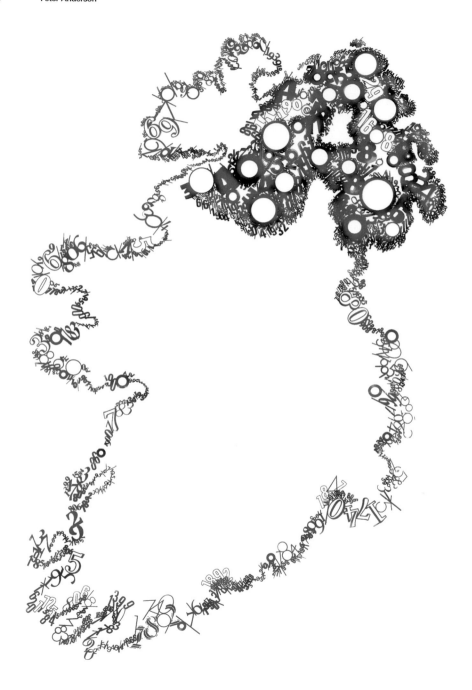

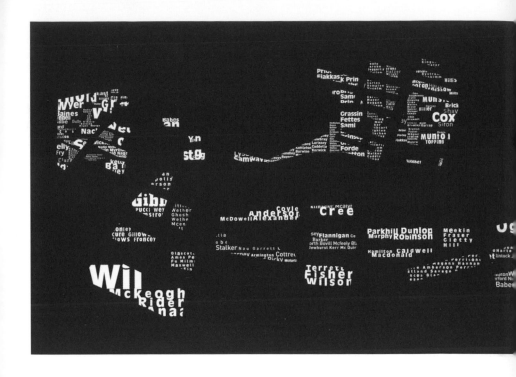

Project
Treble page spread
IT Magazine (issue Experiment).
Also Cayenne Stationary: voucher cover

Title
Moving Surnames, Northern Ireland series 2

Client
IT Magazine. Cayenne.

Year
2001

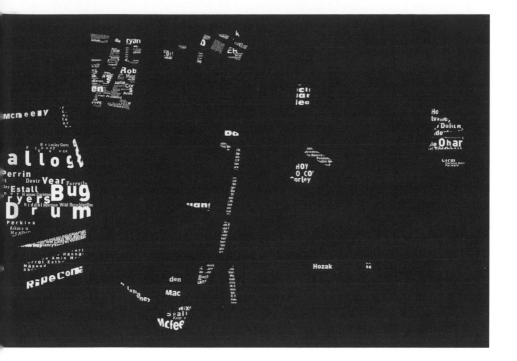

Philippe Apeloig

Philippe Apeloig 41, rue Lafayette, 75009 Paris, France
T +33 1 43 55 34 29 F +33 1 43 55 44 80 E apeloigphilippe@wanadoo.fr www.apeloig.com

"Graphic design is the intersection point between art and communication."

"Having come of age at a time when the computer was introduced and subsequently embraced as a radical new design tool and solution, I and other designers of my generation are seeing it now dominate almost every aspect of design. Design is fundamentally idea-oriented, and designers carry profound influence in their power to shape and communicate cultural concepts. The future of design lies as much in this active and critical role within society as it does in the further development of technology. Graphic design is the art of visualizing ideas, activating space, intuiting proportion. It is the result of meticulous attention to detail. Good graphic design prompts the viewer to meditate, often unconsciously, on potent word/image combinations. Good graphic design is always memorable."

» Da ich in einer Zeit groß geworden bin, in der der Computer aufkam und als radikal neues Gestaltungswerkzeug angewendet wurde, erlebe ich wie andere Grafiker meiner Generation, dass er fast das ganze grafische Gestalten beherrscht. Unsere Arbeit beruht auf Ideen und wir Grafiker üben mit unserer Vermittlung kultureller Konzepte tief greifenden Einfluss aus. Die Zukunft unserer Zunft liegt ebenso in dieser kritischen Rolle wie in der technischen Weiterentwicklung. Grafikdesign ist die Kunst, Gedanken zu visualisieren, Flächen und Räume zu aktivieren und Proportionen zu erspüren. Sie ist das Ergebnis minutiöser Detailarbeit. Gutes Grafikdesign lässt den Betrachter – oft unbewusst – über eindringliche Text-Bild-Kompositionen nachdenken. Gutes Grafikdesign bleibt immer im Gedächtnis haften.«

« Les graphistes semblent se libérer de l'utilisation systématique de l'ordinateur, qui a été considéré comme l'outil miracle capable de résoudre tous les problèmes graphiques. Le design est une question de concept et de communication. Notre avenir sera guidé par le développement des nouvelles technologies et par le rôle actif et critique des designers dans la société. Certes il ne s'agit pas de négliger les aspects techniques : la composition d'une page, le souci des proportions, la qualité de la typographie et l'usage des couleurs ; mais le graphisme est avant tout l'art de visualiser des idées. J'aime qu'une affiche donne l'idée de mouvement, de spontanéité, et cela résulte d'un contrôle minutieux de chaque détail. Je veux interpeller le public, le pousser à méditer sur la combinaison entre mot(s) et image(s). Le résultat doit se fixer dans la mémoire. »

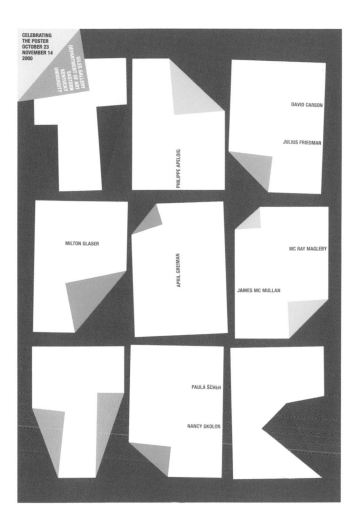

Project
Poster for a group exhibition

Title
Celebrating the Poster

Client
Eastern Kentucky University, Richmond,
USA

Year
2000

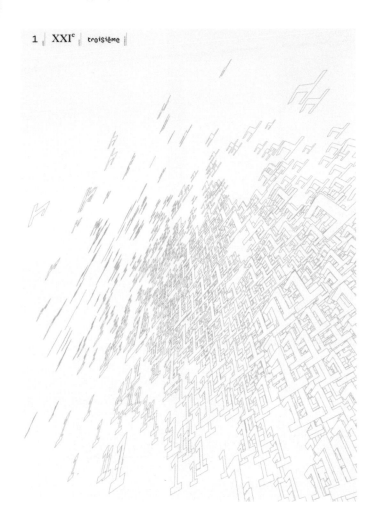

1 | XXIe | troisième |

Opposite page:

Project
New Year's Eve Card

Project
Poster for Linotype, Essen, Germany

Title
New Year's Eve Card

Title
3rd Design Type Contest Linotype

Client
Philippe Apeloig Studio

Client
Linotype

Year
2001

Year
1999

■ Call for entries

3. Type Design Contest

3rd International
Digital Type
Design Contest.
Deadline:
October, 31, 1999

Put your own creations
to the test!
Send us your best
digital font(s).
An international jury
will choose the winners
in four font categories.

Categories:	Jury:	Winning awards
1. Text Fonts	Andrew Boag (UK)	total of 40,000 DM
2. Headline Fonts	Irma Boom (NL)	For detailed contest
3. Experimental Fonts	Adrian Frutiger (CH)	conditions see reverse
4. Symbols	Gabriele Günder (D)	
	Bernd Möllenstädt (D)	
	Jean François Porchez (F)	
	Wolfgang Weingart (CH)	

August Media

August Media Studio 6, The Lux Building, 2-4 Hoxton Square, London N1 6NU, UK
T +44 20 7684 6535 F +44 20 7684 6525 E scoates@augustprojects.demon.co.uk

"What is special about our studio is that we are a collective of editors, writers, publishers and designers. The exchange of ideas between these specialisms gives our work a particular perspective."

"Designers will learn to read and write."

» Grafiker werden lesen und schreiben lernen.«

« Les créateurs apprendront à lire et à écrire. »

Opposite page:

Project
Cover of exhibition catalogue

Title
Flying over Water

Client
Merrell Holberton

Year
1997

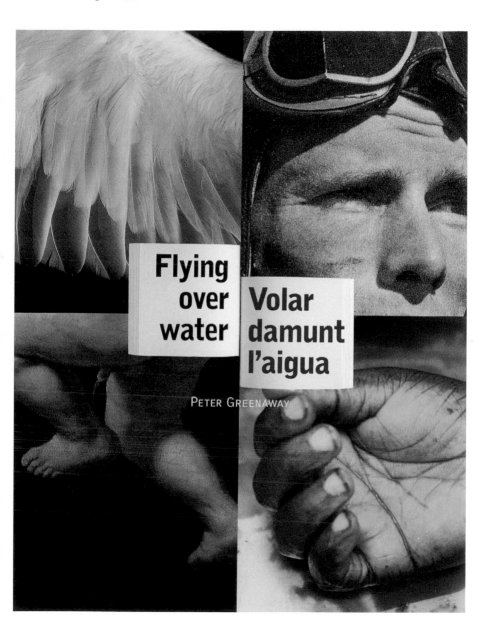

Flying over water

Volar damunt l'aigua

PETER GREENAWAY

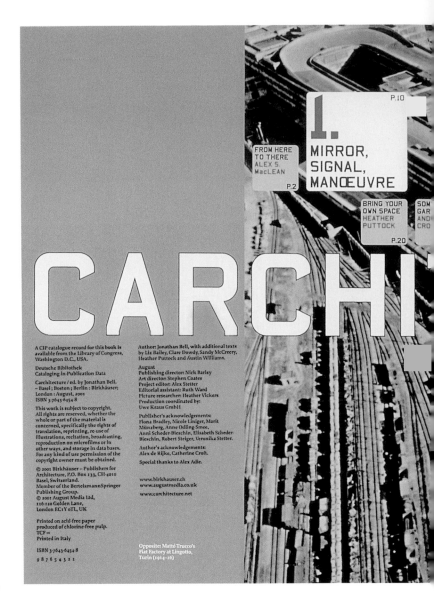

1.

P.10

FROM HERE
TO THERE
ALEX S.
MacLEAN

P.2

**MIRROR,
SIGNAL,
MANŒUVRE**

BRING YOUR
OWN SPACE
HEATHER
PUTTOCK

SOM
GAR
AND
CRO

P.20

CARCHI

A CIP catalogue record for this book is available from the Library of Congress, Washington D.C., USA.

Deutsche Bibliothek Cataloging-in-Publication Data

Carchitecture / ed. by Jonathan Bell. - Basel ; Boston ; Berlin : Birkhäuser; London : August, 2001
ISBN 3-7643-6454-8

© 2001 Birkhäuser – Publishers for Architecture, P.O. Box 133, CH-4010 Basel, Switzerland.
Member of the BertelsmannSpringer Publishing Group.
© 2001 August Media Ltd, 116-120 Golden Lane, London EC1Y 0TL, UK

Printed on acid-free paper produced of chlorine-free pulp.
TCF ∞
Printed in Italy

ISBN 3-7643-6454-8

9 8 7 6 5 4 3 2 1

Author: Jonathan Bell, with additional texts by Liz Bailey, Clare Dowdy, Sandy McCreery, Heather Puttock and Austin Williams.

August
Publishing director: Nick Barley
Art director: Stephen Coates
Project editor: Alex Stetter
Editorial assistant: Ruth Ward
Picture researcher: Heather Vickers
Production coordinated by: Uwe Kraus GmbH

Publisher's acknowledgements:
Fiona Bradley, Nicole Liniger, Marit Münzberg, Anne Odling-Smee, Anni Scheder-Bieschin, Elisabeth Scheder-Bieschin, Robert Steiger, Veronika Stetter.

Author's acknowledgements:
Alex de Rijke, Catherine Croft.

Special thanks to Alex Adie.

www.birkhauser.ch
www.augustmedia.co.uk
www.carchitecture.net

Opposite: Matté Trucco's
Fiat Factory at Lingotto,
Turin (1914-26)

Project
Book spread

Title
Carchitecture

Client
August / Birkhäuser

Year
2001

Jonathan Barnbrook

Jonathan Barnbrook Barnbrook Studios, Studio 12, 10–11 Archer Street, London W1D 7AZ, UK
T +44 20 7287 3848 F +44 20 7287 3601 E virus@easynet.co.uk

"Language is a virus, money is a nasty disease."

"There was a time when it was thought that design had an important role in society. It could tell people meaningful information or try to improve our ways of living. Today we seem to have forgotten that design has this possibility. The kind of work that designers seek are the ones for the coolest sports companies, not the ones that will have the most effect on society or add most to culture. It is time for designers to realise that design is not just something 'cool' and that design is also not just about money. We need to take our profession seriously and engage in cultural and critical discussion about what we are doing and aiming for. The modernist idea that designers are transparent messengers with no opinions of their own is no longer valid. We cannot just do our design and say issues such as unethical work practices are not our problem. We cannot say that a lack of meaningful content is not a problem. If we want the respect and attention we think we deserve, then we need to think about what happens to our work when it is seen in society and about the kind of work we want to participate in. Design STILL has the potential to change society and we should start remembering this once more."

» Es gab einmal eine Zeit, in der man Design eine bedeutende gesellschaftliche Rolle zuschrieb. Es konnte sinnvolle Informationen übermitteln oder versuchen, unsere Lebensart zu verbessern. Heute scheinen wir das vergessen zu haben. Grafiker bemühen sich um Aufträge von den coolsten Sportartikelherstellern und nicht von denen, die am meisten für Gesellschaft und Kultur tun. Es ist an der Zeit, dass sich Grafikdesigner bewusst machen, dass es nicht nur darum geht, cool zu sein und Geld zu verdienen. Wir müssen unseren Beruf ernst nehmen und uns an der kritischen Kulturdebatte über unser Tun und unsere Ziele beteiligen. Das Bild vom Gestalter als bloßem Vermittler ohne eigene Ansichten ist längst überholt. Wir können nicht nur an unseren Entwürfen arbeiten und behaupten, Fragen wie unwürdige Produktionspraktiken gingen uns nichts an, das Fehlen sinnvoller Inhalte sei nicht unser Problem. Wenn wir uns die Anerkennung verschaffen wollen, die wir unserer Meinung nach verdienen, müssen wir uns gut überlegen, was unsere Arbeit bewirkt und uns nach Auftraggebern umschauen, die wir unterstützen möchten. Das Grafikdesign hat immer noch das Potenzial, die Gesellschaft zu verändern, und das sollten wir uns wieder ins Gedächtnis rufen.«

« Il fut un temps où l'on pensait que le graphisme jouait un rôle important dans la société. Il pouvait transmettre aux gens des informations utiles ou tenter d'améliorer nos conditions de vie. Aujourd'hui, on semble avoir oublié ces fonctions. Les créateurs cherchent avant tout à travailler pour les compagnies de sport les plus branchées plutôt que sur des projets susceptibles d'avoir un effet sur la société ou d'enrichir la culture. Il serait temps qu'ils se rendent compte que le design n'est pas qu'une affaire ‹branchée› de gros sous. Nous devons prendre notre profession au sérieux et engager un débat culturel et critique sur ce que nous faisons et ce que nous recherchons. L'idée moderniste selon laquelle le graphiste serait un messager transparent sans opinion personnelle n'est plus valable. Nous ne pouvons plus nous contenter de livrer nos travaux en déclarant que des questions telles que le respect de l'éthique professionnelle ne nous concernent pas. Nous ne pouvons plus dire que l'absence d'un contenu qui ait un sens n'est pas un problème. Si nous voulons le respect et l'attention que nous pensons mériter, nous devons le livrer lorsque devient notre travail une fois lancé dans la société et sur le type de projets auxquels nous avons envie de participer. Le design a ENCORE le potentiel de changer la société. Ne l'oublions plus. »

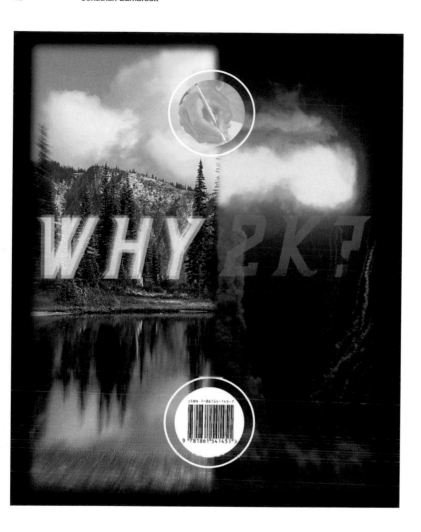

Project
Why2K? A book published for the
Millennium featuring excerpts of British
writing from the past 150 years

Title
Cover for 'Why2K?'

Client
Booth-Clibborn Editions

Year
2000

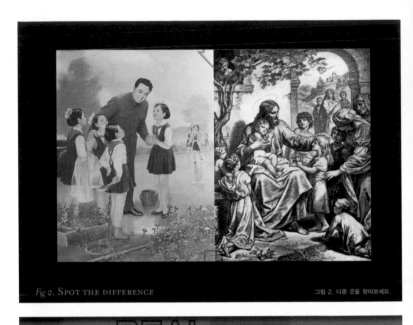

Fig 2. SPOT THE DIFFERENCE 그림 2. 다른 곳을 찾아보세요.

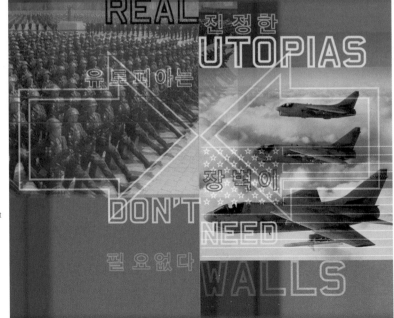

Project
A series of works that
appeared in a South
Korean magazine about
the North Korean
regime

Title
North Korea: building
the brand

Client
Self-published

Year
2001

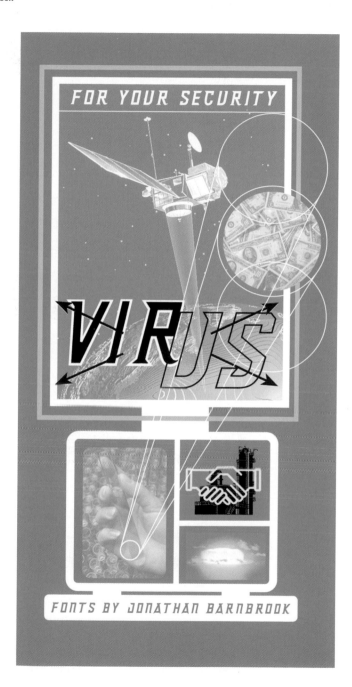

Project
A leaflet for the font company
Virus set up to release the fonts of
Jonathan Barnbrook

Title
For Your Security, Virus leaflet
cover

Client
Self-published

Year
1999

Ruedi Baur

Ruedi Baur Intégral, Ruedi Baur et Associés, 5, rue Jules Vallès, 75011 Paris, France
T +33 1 55 25 81 10 F +33 1 43 48 08 07 E atelier@integral.ruedi-baur.com

"The questions that concern me are not simply those of graphic design but issues of orientation, identification and information."

"Graphic design is merely one tool among many intended to resolve questions related to orientation, identification and information. In the future we must further enhance our teamwork, and realise in more effective fashion our interdisciplinary approach; respond even better to questions of sense and message, given today's superabundance of ambient information; attempt to break down the barriers between art and design, and between self-initiated and commissioned work; further transcend the limitations of graphic design."

» Die angewandte Grafik ist nur ein Medium von vielen, die in der Lage sind, die mit Orientierung, Identifikation und Information einhergehenden Fragen zu lösen. In Zukunft müssen wir noch besser im Team zusammenarbeiten und unsere Projekte in noch stärkerem Maße interdisziplinär entwickeln, und zwar im Hinblick auf die Überfülle der von allen Seiten auf uns einstürmenden Informationen. Künftig müssen wir versuchen, die Barrieren zwischen Kunst und Gebrauchsgrafik zu durchbrechen, zwischen dem freien Schaffen und Auftragsarbeiten. In Zukunft müssen wir die Grenzen des Grafikdesigns noch weiter als bisher überschreiten.«

« Le graphisme n'est qu'un outil parmi d'autres susceptible de résoudre les questions liées à l'orientation, l'identification et l'information. Il nous faut à l'avenir encore mieux travailler en équipe, encore mieux aborder nos projets avec une approche transdisciplinaire. Il nous faut à l'avenir encore mieux répondre aux questions de sens, de message, dans le contexte de surabondance d'informations qui nous entoure. Il nous faut à l'avenir tenter de briser les limites entre l'art et le design, entre le travail d'auteur et le travail de commande. Il nous faut à l'avenir encore mieux dépasser les limites du graphic design. »

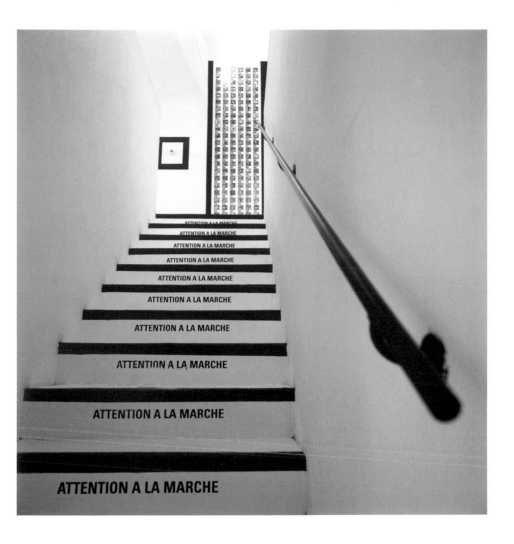

Project
Personal exhibition

Title
Installation U. Eur. + CH ou other nationali-
ties, Strasbourg

Client
La Chaufferie

Year
1999

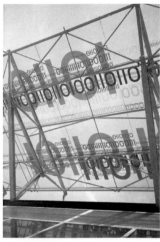

Opposite page:

Project
Design of the façade and signage for the
Ésisar school

Title
Ésisar Valence

Client
DDE de la Drôme, rectorat de l'académie
de Grenoble, Drac Rhône-Alpes

Year
1997

Project
Design of the façade and signage for the
Ésisar school

Title
Ésisar Valence

Client
DDE de la Drôme, rectorat de l'académie
de Grenoble, Drac Rhône-Alpes

Year
1997

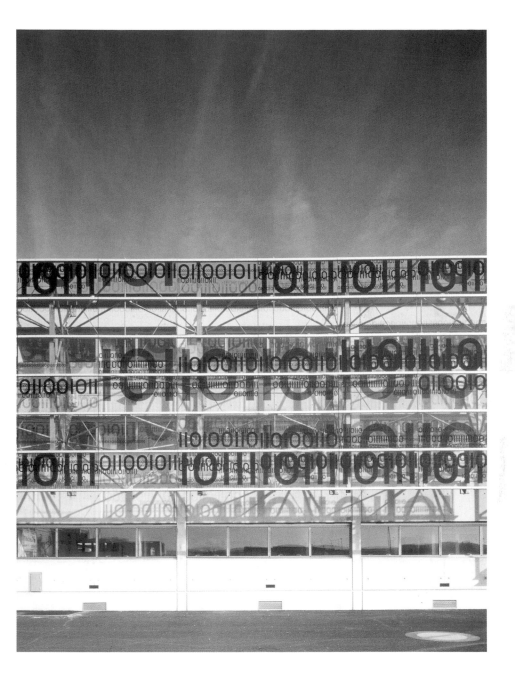

Bump

Bump 5d Rosemary Works, Branch Place, London N1 5PH, UK
T +44 20 7729 4877 F +44 20 7739 4854 E bump@btconnect.com

"Honesty, Humour, Integrity, Boredom, Anger, Deceit."

"Teeth that don't need brushing, Cars that drive themselves, Duodesic Domes over City Centres so you don't get wet when it rains, Shoes that never wear out, Dogs that don't need walking, Robots that will iron your pants, Matter travel will be a thing of the past."

»Zähne, die nicht mit der Bürste geputzt werden müssen; Autos, die ohne Fahrer fahren; geodätische Kuppeln über Stadtzentren, damit man vom Regen nicht nass wird; Schuhe, die ewig halten; Hunde, die nicht Gassi geführt werden müssen; Roboter, die deine Hosen bügeln; tatsächliches Reisen wird der Vergangenheit angehören.«

«Des dents qui n'ont pas besoin d'être brossées. Des voitures qui se conduisent toutes seules. Des dômes géodésiques au-dessus des villes pour ne pas se mouiller quand il pleut. Des souliers qui ne s'usent jamais. Des chiens qu'on n'est plus obligé de promener. Des robots qui repassent les pantalons. Le voyage à travers la matière appartiendra au passé.»

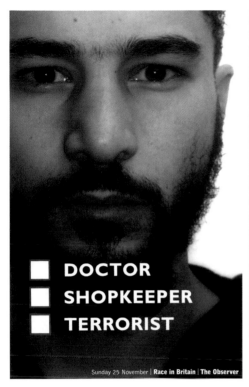

DOCTOR
SHOPKEEPER
TERRORIST

Sunday 25 November | **Race in Britain** | **The Observer**

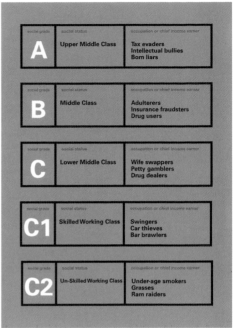

social grade	social status	occupation or chief income earner
A	Upper Middle Class	Tax evaders Intellectual bullies Born liars
B	Middle Class	Adulterers Insurance fraudsters Drug users
C	Lower Middle Class	Wife swappers Petty gamblers Drug dealers
C1	Skilled Working Class	Swingers Car thieves Bar brawlers
C2	Un-Skilled Working Class	Under-age smokers Grasses Ram raiders

Project
The Observer Race Audit advert

Title
Doctor, Shopkeeper, Terrorist

Client
Ogilvy and Mather

Year
2001

Project
T-shirt collaboration

Title
ABC 123

Client
Beams / Jipi Japa

Year
2002

Büro Destruct

Büro Destruct Wasserwerkgasse 7, 3011 Berne, Switzerland
T +41 31 312 63 83 F +41 31 312 63 07 E bd@bermuda.ch
www.burodestruct.net www.typedifferent.com

"surprising – smiling – giving into that eerie feeling delivered to you by buro destruct"

"We are not interested in the future of graphic design. We are living in the present of graphic design. Tomorrow will be another present day."

» Die Zukunft des Grafikdesigns interessiert uns nicht. Wir leben in der Gegenwart des Grafikdesigns. Morgen wird wieder heute sein.«

« Nous ne nous intéressons pas à l'avenir de la création graphique. Nous vivons dans le présent du graphisme. Demain sera un autre aujourd'hui. »

Opposite page:

Project
Monthly programme poster (B4)

Title
Love May

Client
Kulturhallen Dampfzentrale

Year
2001

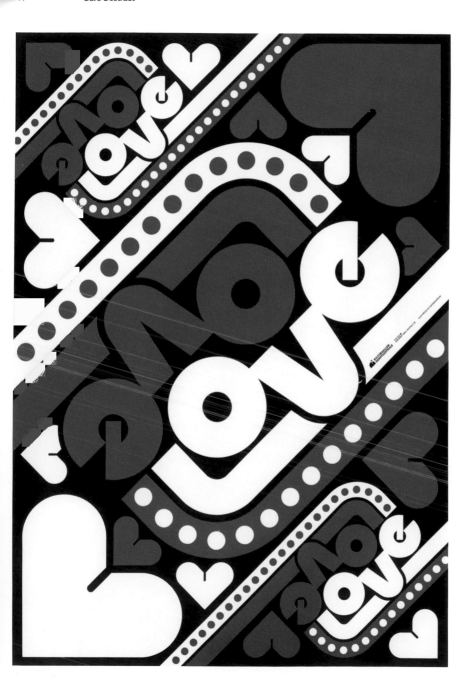

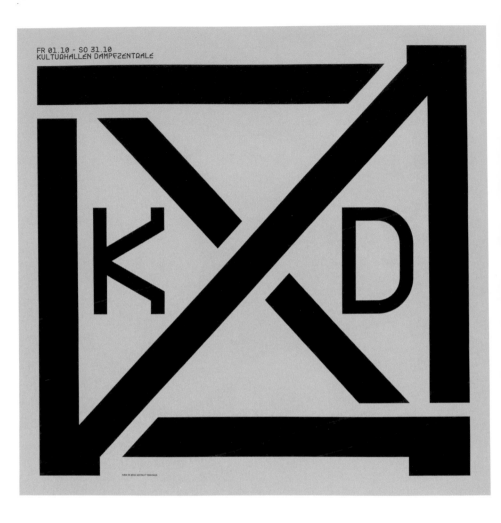

Opposite page:

Project
Monthly programme poster

Project
Nisen Exhibition

Title
KD Kiste

Title
BD-City 2.000

Client
Kulturhallen Dampfzentrale

Client
Nisen Tokyo

Year
1999

Year
1999

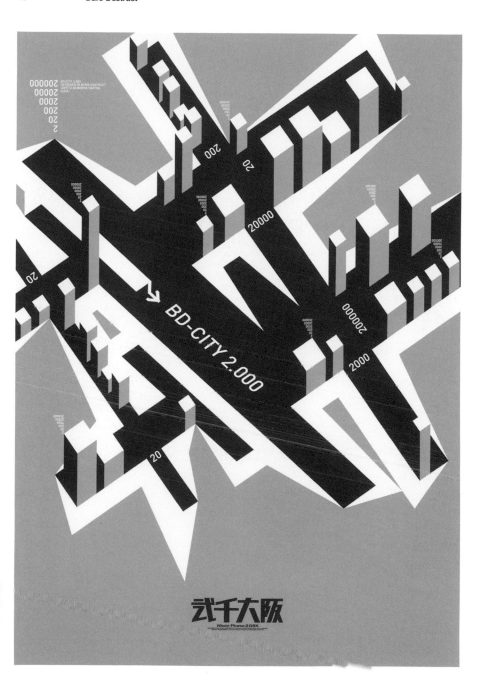

büro für form

büro für form Hopf & Wortmann, Hans-Sachs-Strasse 12, 80469 Munich, Germany
T +49 89 26 949 000 F +49 89 26 949 002 E info@buerofuerform.de www.buerofuerform.de

"Good graphic design is the result of the endless search for beauty in things."

"While the boundaries within the possibilities of design are changing day by day, the creators are becoming more responsible for the messages hidden in every piece of their work. Graphic design will spread a lot more than simple matter, beauty, emotions or style. It could even be a vision for life. The only thing missing so far is a bit more pathos …"

»Weil sich die Grenzen innerhalb der Möglichkeiten des Grafikdesigns ständig verschieben, tragen die Gestalter immer mehr Verantwortung für die Botschaften, die in jeder ihrer Arbeiten versteckt sind. Grafikdesign wird viel mehr verbreiten als nur Dinge, Schönheit, Gefühle oder Stil. Es könnte sogar zur Lebensart werden. Das Einzige, was noch fehlt, ist ein bisschen mehr Pathos …«

« Si les frontières au sein des possibilités graphiques reculent sans cesse, les créateurs sont de plus en plus responsables des messages cachés dans tous les éléments de leur travail. Le graphisme s'étendra bien au-delà de la simple matière, beauté, émotion et style. Il pourrait devenir une vision de la vie. Il ne lui manque à présent qu'un petit peu plus de pathos… »

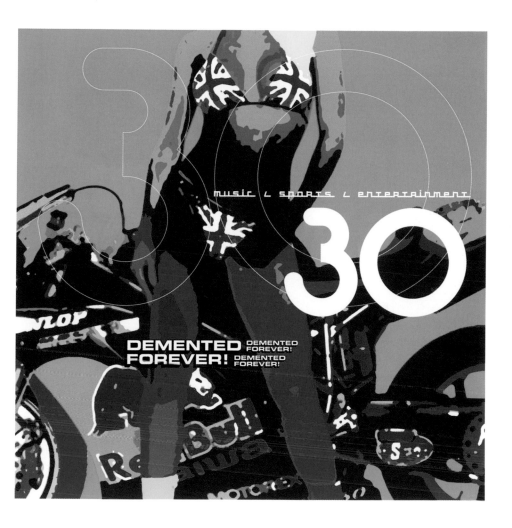

Project
Demented Forever Series Part 03
60 x 60 cm lightbox images

Title
Demented Forever Series

Client
Erste Liga Gastronomie GmbH

Year
2001

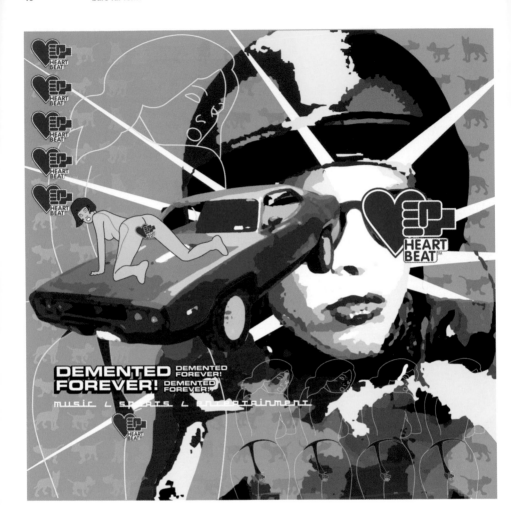

Project
Demented Forever Series Part 01
60 x 60 cm lightbox images

Title
Demented Forever Series

Client
Erste Liga Gastronomie

Year
2001

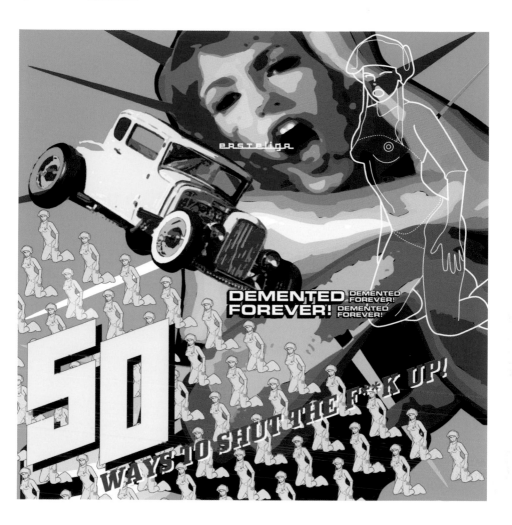

Project
Demented Forever Series Part 04
60 x 60 cm lightbox images

Title
Demented Forever Series

Client
Erste Liga Gastronomie

Year
2001

François Chalet

François Chalet Prima Linea, 52, boulevard du Montparnasse, 75015 Paris, France
T +33 1 53 63 23 00 F +33 1 53 63 23 01 E bonjour@françois-chalet.ch E agency@primalinea.com
www.francoischalet.ch www.primalinea.com

"Graphic design – a smiling cat with a tie."

"More cats, more dogs. In the future there will be more cats, black ones, white ones, blue ones, but there also will be more dogs. I don't like dogs. The cats will have to be clever, because they will be in the minority as they always have been. They are also smaller than dogs. So, things will change, it's the eternal story of dogs and cats."

» Mehr Katzen, mehr Hunde. In Zukunft wird es mehr Katzen geben – schwarze, weiße, blaue –, aber auch mehr Hunde. Ich mag Hunde nicht. Die Katzen werden clever sein müssen, denn sie werden – wie schon immer – in der Minderheit sein. Außerdem sind sie kleiner als die meisten Hunde. So wird sich alles ändern, das ist die ewige Geschichte von Hunden und Katzen.«

« Plus de chats, plus de chiens. A l'avenir, il y aura plus de chats, des noirs, des bleus, mais il y aura aussi plus de chiens. Je n'aime pas les chiens. Les chats devront être malins, parce qu'ils seront en minorité, comme toujours. Ils sont aussi plus petits que les chiens. Donc, les choses changeront, c'est l'éternelle histoire des chiens et des chats. »

Opposite page:

Project
Illustration

Title
Education meets Business

Client
Swissair gazette,
Switzerland

Year
2001

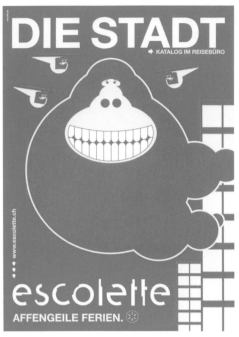

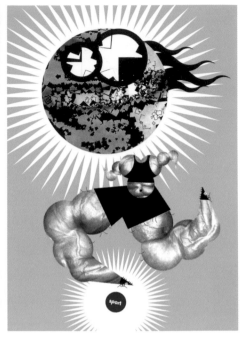

Project
Poster for campaign

Title
Die Stadt

Client
Escolette (CH)
Agency: fam. müller

Year
2000

Project
Illustration

Title
Sport

Client
Gruntz (CH)

Year
2002

Opposite page:

Project
Illustration

Title
Berlin

Client
Berliner

Year
2001

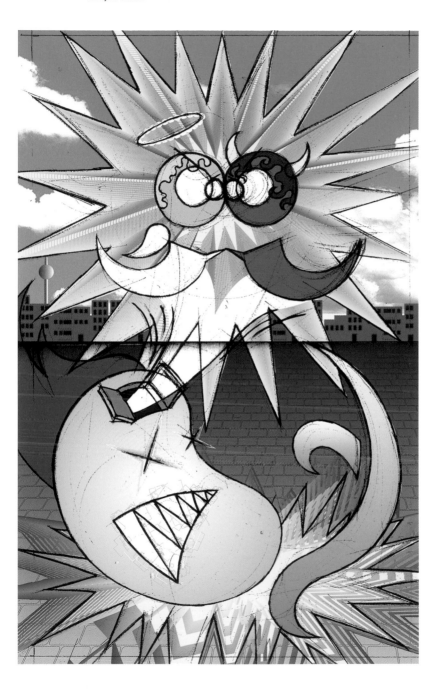

Warren Corbitt

Warren Corbitt 54 West 21st Street, Suite 501, New York City, NY 10010, USA
T +1 212 929 7828 F +1 212 929 7638 E warren@one9ine.com

"What is thought to be the edge is only the beginning."

"Shift and progression are implicit to any process of making. When one goes about the daily practice of manufacturing meaning – of defining points of access, framing the interaction, and ultimately determining the entry and exit points – it is only natural that the shifts in the space WE inhabit, the ontological sac of being, will be influenced, will be bumped. This is nothing new – but what is peeping through the haze is the recognition that the image makers in our midst do more than make pretty pictures."

» Wechsel und Fortschritt gehören implizit zu jedem Herstellungsprozess. Wenn man täglich mit der Praxis der Produktion zu tun hat – damit, Zugangspunkte zu definieren, den Interaktionsrahmen und schließlich die Anfangs- und Endpunkte festzulegen –, dann ist es nur natürlich, dass der von uns bewohnte Raum sich verändert, dass der ontologische Beutel des menschlichen Seins beeinflusst und gerüttelt wird. Das ist nicht neu, aber durch den Nebel schimmert die Erkenntnis, dass die Bildermacher in unserer Mitte mehr tun als nur hübsche Bildchen zu erzeugen.«

« Le déplacement et la progression sont implicites dans tout processus de réalisation. Lorsqu'on s'attache quotidiennement à fabriquer du sens, à définir des points d'accès, à encadrer l'interaction et enfin à déterminer les points d'entrée et de sortie, il est normal que les glissements de l'espace que NOUS habitons, la poche d'existence ontologique, en soient affectés, bousculés. Cela n'a rien de nouveau mais à travers le brouillard pointe la reconnaissance que les faiseurs d'images parmi nous font plus que de fabriquer de jolies images».

Opposite page:

Project
Magazine spread

Title
periphery

Client
Raygun Magazine,
Los Angeles, CA, USA

Year
1998

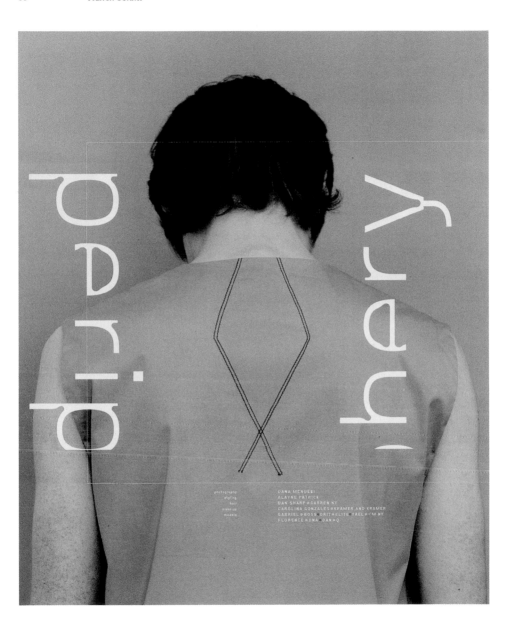

photography DANA MENUESI
styling ALAYNE PATRICK
hair DAN SHARP @ CARREN NY
make-up CAROLINA GONZALES @ KRAMER AND KRAMER
models GABRIEL @ BOSS DRIT @ ELITE YAEL @ I'M NY
FLORENCE @ DNA DAN @ Q

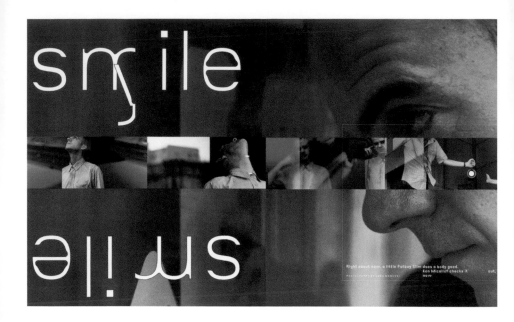

Project
Magazine spread

Title
smiley smile

Client
Raygun Magazine, Los Angeles, CA, USA

Year
1998

Opposite page:

Project
Interactive piece for
"The Remedi Project"

Title
implicit proportion

Client
Self-published for
"The Remedi Project"

Year
2000

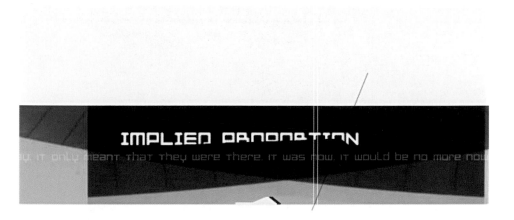

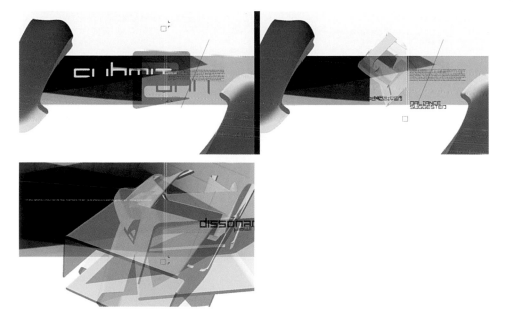

DED Associates

DED Associates Ltd. The Workstation, 15, Paternoster Row, Sheffield S1 2BX, UK
T +44 114 2493939 F +44 114 2493940 E ded@dedass.com www.dedass.com

"I am a camera!"

"The evolution of Graphic Design is intrinsically linked to the evolution of the tools by which we deliver those designs. Whilst the fundamentals will remain fixed – 'the necessity to provoke a response through visual means' – the process by which we arrive at that response will be driven by such forces as the homogenising of software and technology, as well as that of cultures and the quest for ever increased speed in communication. It is through the fervent nature of tools such as the internet, which allows the innovative and eager individual as much favour as those key figures or groups already established. It is here that new visual forms of communication will grow and envelop us all."

» Die Geschichte der Gebrauchsgrafik ist eng verknüpft mit der Entwicklung der Arbeitsmittel, mit denen wir die Grafiken erstellen. Während die Grundlagen dieselben bleiben – die Notwendigkeit, mit visuellen Mitteln eine Reaktion hervorzurufen – wird der Prozess, mit dessen Hilfe wir die Reaktion erzeugen, von Kräften wie der Homogenisierung von Software und Technologie sowie von Kulturen und der Suche nach immer schnelleren Kommunikationsmöglichkeiten bestimmt werden. Die ungestüme Natur von Arbeitsmitteln wie dem Internet lässt innovativ denkende dynamische Individuen ebenso zum Zug kommen wie bereits etablierte Schlüsselfiguren oder Gruppen. Hier werden neue Formen der visuellen Kommunikation entstehen und uns alle umgeben.«

« L'évolution de la création graphique est intrinsèquement liée à celles des outils qui nous permettent de concevoir nos travaux. Si les bases fondamentales restent les mêmes («la nécessité de susciter une réaction par un moyen visuel»), le processus par lequel nous atteindrons cette réaction sera déterminé par des forces telles que l'homogénéisation des logiciels, de la technologie et des cultures, ainsi par que la quête de moyens de communication toujours plus rapides. Des outils tels qu'Internet apporteront au particulier inventif et déterminé les mêmes avantages qu'aux créateurs éminents ou aux groupes déjà établis. C'est à ce niveau que de nouvelles formes de communication se développeront et nous engloberons tous. »

Opposite page:

Project
Gifthorse 5

Title
Earth

Client
Sioux Records

Year
2001

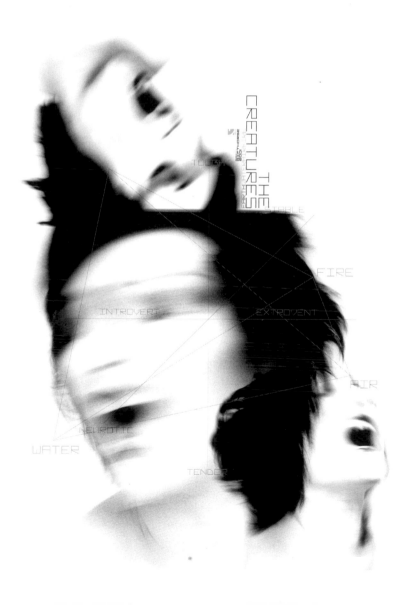

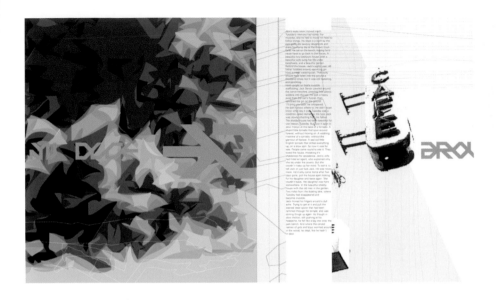

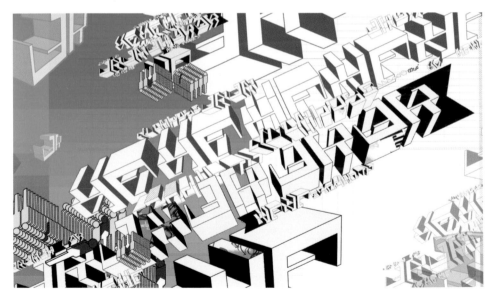

 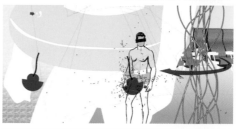

Opposite page:

Project
Travel Sickness

Title
Daddy's Girl/Duck Boys

Client
Die Gestalten Verlag

Year
2000

Project
Do Not Inflate [as this may impede your exit]

Title
Various

Client
Laurence King Publishing

Year
2001

Dextro

Dextro
E dextro@dextro.org

"Access to the subconscious by the use of cannabis."

"Peace by rehabilitating the right hemisphere of the brain."

» Frieden durch rehabilitierung der rechten gehirnhälfte.«

« La paix par la réhabilitation de l'hémisphère droit du cerveau. »

Opposite page:

Project
dextro.org

Title
/

Client
Self-published

Year
1993

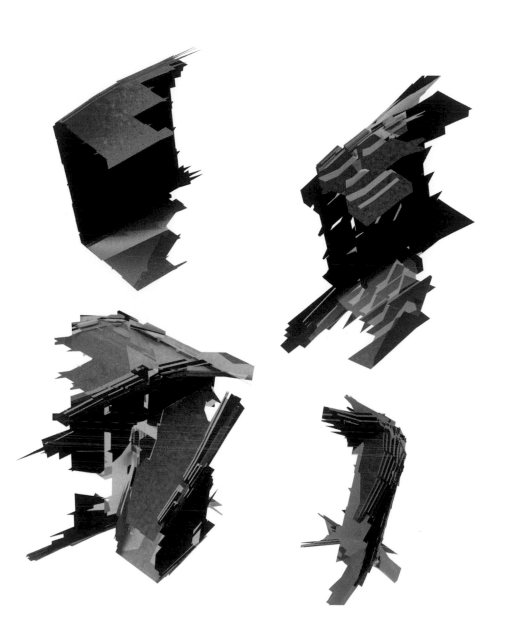

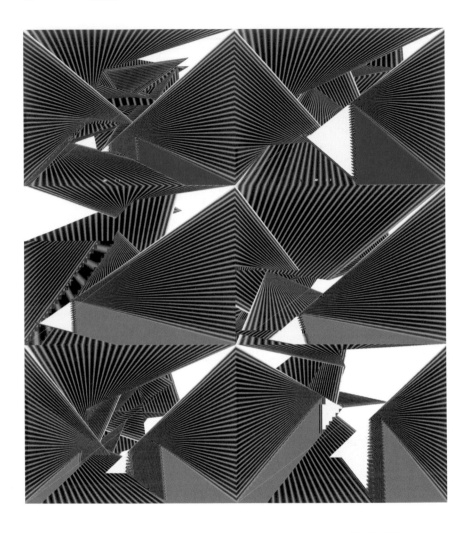

Opposite page:

Project
dextro.org

Title
/

Client
Self-published

Year
1999

Project
dextro.org

Title
/

Client
Self-published

Year
1993

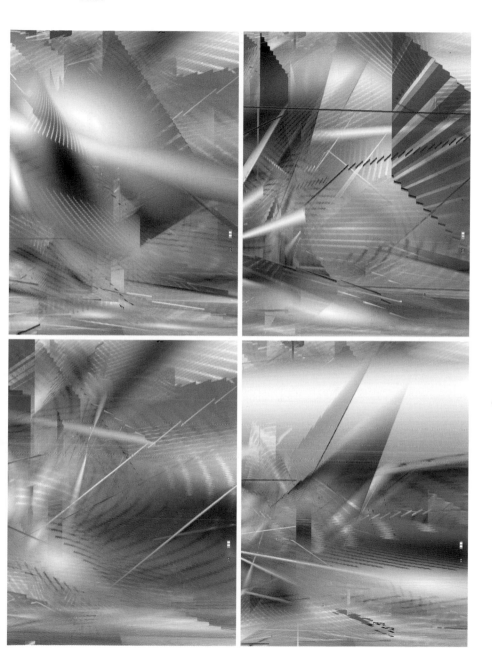

Farrow Design

Farrow Design 23–24 Great James Street, Bloomsbury, London WC1N 3ES, UK
T +44 20 7404 4225 F +44 20 7404 4223 E studio@farrowdesign.com www.farrowdesign.com

"A designer is duty bound to push the client as far as they will go."

"Clarity, Form, Function." » Klarheit, Form, Funktion.« « Clarté, forme, fonction.»

Project
CD packaging
Sculpture: Yoko by Don Brown courtesy
of Sadie Coles HQ

Title
Spiritualized
Let it come down

Client
Spaceman/Arista

Year
2001

Released
08 03 99

Available on
2xCD and 12"

Orbital Style

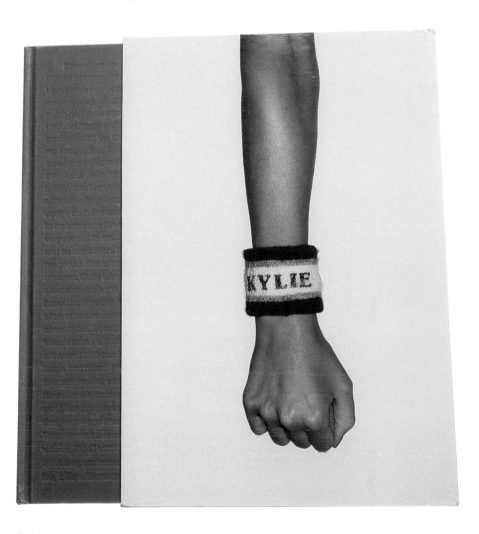

Opposite page:

Project
Poster

Title
Orbital
Style

Client
London Records

Year
1999

Project
Book design

Title
Kylie

Client
Darenote Ltd /
Booth-Clibborn Editions

Year
1999

Dávid Földvári

Dávid Földvári Big Photographic, Warehouse D4, Metropolitan Wharf, Wapping wall, London E1W 3SS, UK
T +44 20 7488 0794 F +44 20 7702 9366 E bp@bigactive.com www.bigactive.com

"Ugly=Beautiful"

"There is still a fear of the unknown and a lack of trust that exists in current art direction, which in turn leads to designers and illustrators all too often producing comfortable and unchallenging work in order to survive. This leads to the mass media being flooded with an endless amount of visual information that essentially all looks the same, and as a result it fails to excite or convey anything new. Graphic designers and illustrators aren't machines that can churn out the same product endlessly, and the most successful projects are always those that allow for creative freedom and experimentation."

» Unter Artdirectoren herrscht immer noch Angst vor allem Unbekannten und mangelndes Vertrauen, was Grafiker und Illustratoren allzu oft dazu veranlasst, gefällige und unprovokante Entwürfe zu produzieren, um zu überleben. Das führt dazu, dass die Massenmedien mit einer ausufernden Flut visueller Informationen überladen werden, die im Wesentlichen alle gleich aussehen und weder aufregend sind noch etwas Neues bringen. Grafiker und Illustratoren sind keine Maschinen, die kontinuierlich das immer gleiche Produkt ausstoßen können, und am erfolgreichsten sind schließlich immer die Projekte, die schöpferische Freiheit und Experimente zugelassen haben.«

« La peur de l'inconnu et la méfiance perdurent parmi les directeurs artistiques d'aujourd'hui. Du coup, les graphistes et les illustrateurs produisent trop souvent des travaux pépères et sans grand intérêt pour survivre. Les médias se retrouvent ainsi inondés d'un flot ininterrompu d'informations visuelles où tout se ressemble, n'apportant rien de nouveau ni d'excitant. Les créateurs ne sont pas des machines qui peuvent ressasser le même produit à l'infini et les projets les plus réussis sont toujours ceux qui laissent la part belle à la liberté, la créativité et l'expérimentation. »

Opposite page:

Project
Personal work, part of a sequence of five images

Title
We believe

Client
Self-published

Year
2002

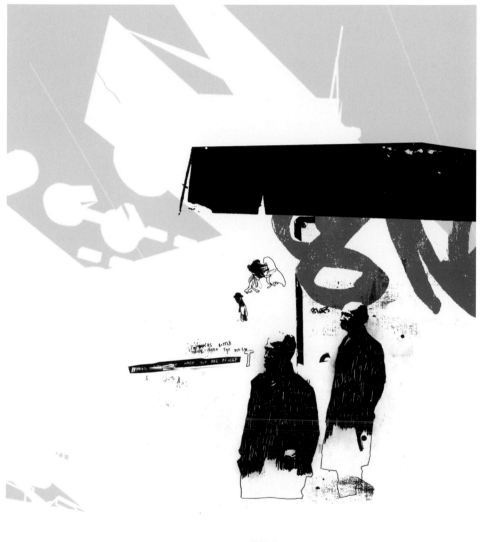

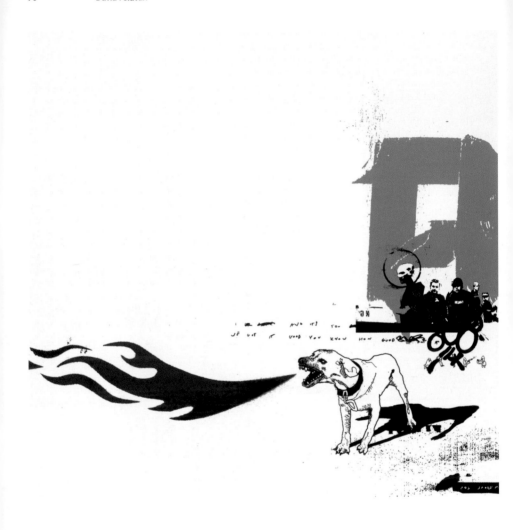

Opposite page:

Project
Single sleeve prototype for the band "A"

Title
Flamespitter (early work in progress for
"Starbucks")

Client
London Records, UK

Year
2002

Project
"Crash and Learn" ad campaign, part of a
sequence of four images

Title
Masochist (Italian version)

Client
Nike ACG, Wieden Kennedy Amsterdam,
The Netherlands

Year
2001

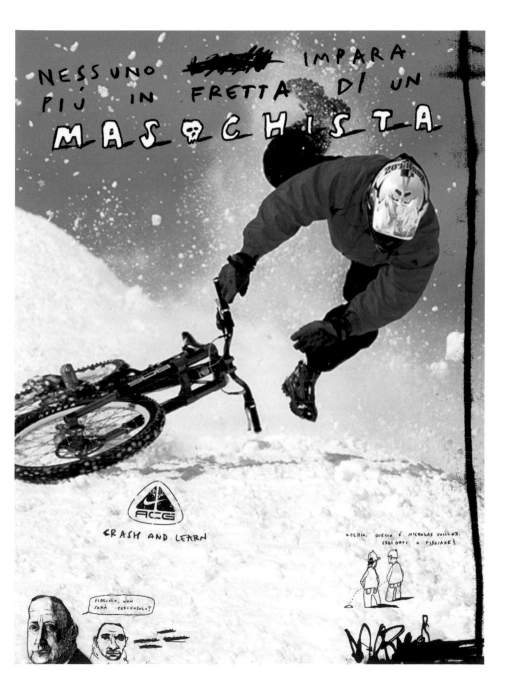

Form

Form 47 Tabernacle Street, London EC2A 4AA, UK
T +44 20 7014 1430 F +44 20 7014 1431 E studio@form.uk.com www.form.uk.com

"The future and past make the present inspiring."

"Simplicity and directness underline the way that we work. There's an honesty in trusting what feels instinctively right, and a strength in accepting one's emotions without hiding behind intellectual pretension and over-laboured strategy. The 21st century is a myriad of graphic ideas and styles – from futuristic to retro, from high street commercialism to underground cool. We don't deliberately set out to create a style. We work with clients to create concepts and solutions that solve their problems, but which also look and feel great to us. We experiment with images, typography and paper stocks, drawing on references that stretch from music and films to fine art. A minimalist layout, for example, counterbalanced with a strong use of imagery, colour and logo design is what drives us. Good design is essentially timeless. Our recent move into clothing with the UniForm label is another example of how we've mixed styles and formats, transferring graphics onto fabrics, experimenting with different printing techniques, materials and finishes. There should be no constraints when it comes to design but there is a certain amount of obsession in continually striving to push the boundaries."

» Einfachheit und Direktheit kennzeichnen unsere Arbeit. Es ist ehrlich, auf das zu vertrauen, was man instinktiv für richtig hält, und es zeugt von Stärke, Gefühle zuzulassen, ohne sich hinter intellektuellen Prätentionen und ausgeklügelten Strategien zu verstecken. Das Grafikdesign des 21. Jahrhunderts wird aus unzähligen grafischen Ideen und Stilen bestehen – von futuristisch bis retro, von Massenwerbung bis subkultur-cool. Wir arbeiten nicht bewusst auf einen eigenen Stil hin. Wir entwickeln zusammen mit unseren Kunden Konzepte und Lösungen, die den Zweck erfüllen, von denen wir aber auch selbst begeistert sind. Wir experimentieren mit Bildern, Typografie und Papiersorten und verarbeiten Elemente aus Musik, Film und bildender Kunst. Ein minimalistisches Layout kombiniert mit kraftvoller Bildsprache, Farben und Logo ist für uns zum Beispiel eine reizvolle Aufgabe. Gutes Design ist im Großen und Ganzen zeitlos. Unser Einstieg ins Modegeschäft mit der Marke UniForm ist ein weiteres Beispiel dafür, wie wir Stile und Anwendungen verbinden: Wir übertragen grafische Entwürfe auf Stoffe und experimentieren mit Stoffdrucktechniken, Materialien und Appreturen. Das Gestalten sollte keinen Zwängen unterliegen, doch hat das ständige Bemühen um die Überwindung von Grenzen etwas von Besessenheit.«

« Nous travaillons dans un style simple et direct. Il y a une honnêteté dans le fait de se fier à ce que l'on ressent instinctivement comme étant correct et une force dans le fait d'accepter ses émotions sans se cacher derrière des prétentions intellectuelles et des stratégies laborieuses. Le XXIe siècle est une myriade d'idées et de styles graphiques. Nous ne cherchons pas délibérément à créer un style. Nous travaillons avec des clients pour concevoir des concepts et des solutions à leurs problèmes mais d'une manière qui nous plaise et nous apporte quelque chose. Nous expérimentons avec des images, des typographies et des textures de papier, puisant nos références dans la musique, le cinéma ou les beaux-arts. Ce qui nous inspire, par exemple, c'est une mise en page minimaliste contrebalancée par une iconographie forte, des couleurs vives et un logo bien dessiné. Notre incursion récente dans le domaine de la mode avec la marque UniForm est une autre illustration de la manière dont nous mélangeons les styles et les formats, transférant les graphismes sur des tissus. En graphisme, il ne devrait pas y avoir de contraintes, mais il y a un côté obsessionnel à vouloir toujours repousser les limites. »

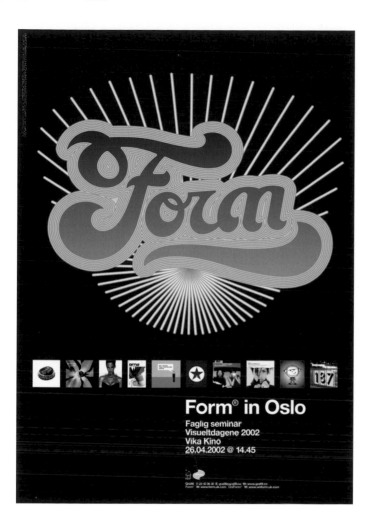

Project
Form promotional poster

Title
Form In Oslo (Homage to Freia)

Client
Self-published

Year
2002

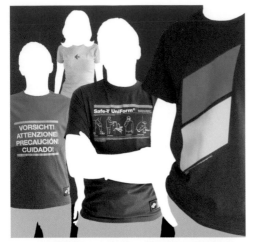

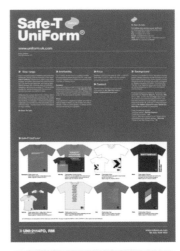

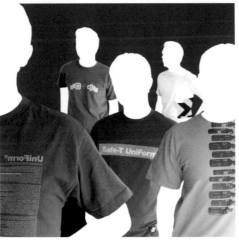

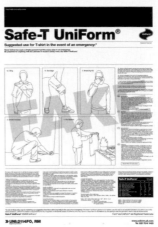

Project
Safe-T UniForm

Title
Safe-T UniForm range and press release

Client
UniForm

Year
2002

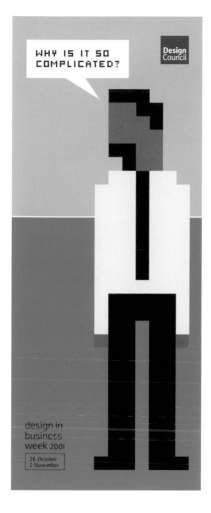

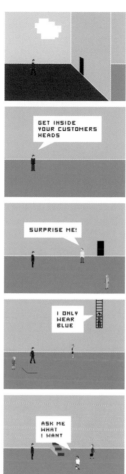

Project
Left: Event banner
Right: Title sequence

Title
design in business week 2001

Client
Design Council

Year
2001

Tina Frank

Tina Frank designby frank/scheikl, Mayerhofgasse 20/6, 1040 Vienna, Austria
T +43 1 505 60 66 E hello@frank.at www.frank.at

"I want you to fall into my pictures and stay with them for some time."

"It will be a 'wow' and a 'zoom', some things going fast, other things really slow. Design will become sound and sound will become design. Design will become anything and everything will become design. Even no-design will be designed. The public nowadays is already much more aware of graphic design than – lets say some 20 years ago. Even the regular school kid already knows the hipster-advantage of the perfect cool logo on their mobile telephones. Design will be needed in even more spaces, places we haven't yet thought about. We will be bombarded with moving design on every little street corner. What the poster-advertisements on the street are now will become big screens with flying pixels. Websites built to function as posters on the streets and used as starting points for the daily soap opera. I don't know yet if I will like it."

» Es wird ›wow‹ machen und ›zoom‹, manche Dinge werden superschnell sein, andere wieder richtig langsam. Design wird zu Sound und Sound wird zu Design. Design wird Nichts werden und alles wird zu Design. Selbst ›non-designte‹-Dinge werden absichtlich so entworfen. Die Öffentlichkeit ist heutzutage bereits viel aufmerksamer auf Design als – sagen wir – vor 20 Jahren. Selbst ein Schulkind kennt bereits den Hipster-Vorsprung, den Coolness-Faktor beim richtigen Logo am Display des eigenen Mobiltelefons. Design wird an immer mehr Stellen benötigt, an Plätzen, an die wir vorher noch gar nicht gedacht haben. Wir werden bombardiert werden mit bewegtem Design an jeder Straßenecke. Was heute die Straßenposter sind, werden in Zukunft riesige Bildschirme mit fliegenden Pixeln sein. Webseiten gebaut als Poster auf der Straße, als Startpunkte für die tägliche Seifenoper. Keine Ahnung, ob mir das gefallen wird …«

«Ce sera un ‹Hou la la!› et un ‹Zoom!›, certaines choses allant vite, d'autres très lentement. La création graphique deviendra sonore et le son deviendra graphique. Le graphisme deviendra tout, et n'importe quoi deviendra du graphisme. Même le non graphisme sera soumis au graphisme. Aujourd'hui, le public est déjà beaucoup plus au fait qu'il y a une vingtaine d'années. L'écolier lambda est déjà conscient de l'image qu'apporte le logo parfaitement cool de son portable. Le graphisme s'imposera dans plus d'espaces, dans des lieux auxquels nous n'avons pas encore pensé. A chaque coin de rue, nous serons bombardés par des graphismes animés. Les grandes affiches d'aujourd'hui seront remplacées par des écrans géants aux pixels volants. Des pages web seront conçues comme des affiches de rue et serviront de points de départ à des feuilletons à l'eau de rose quotidiens. Je ne sais pas encore si ça me plaira beaucoup.»

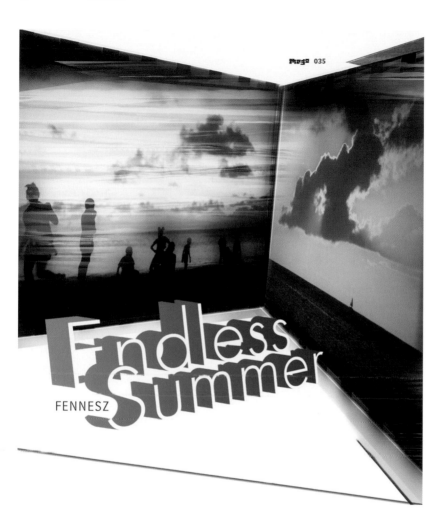

Project
CD Sleeve for MEGO 035:
Endless Summer, by Christian Fennesz

Title
Endless Summer

Client
Mego

Year
2001

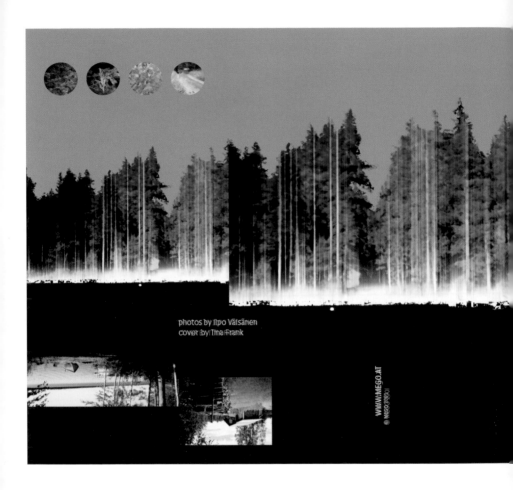

Project
CD Sleeve for MEGO 037: asuma, by Ilpo
Väisänen

Title
asuma

Client
Mego

Year
2001

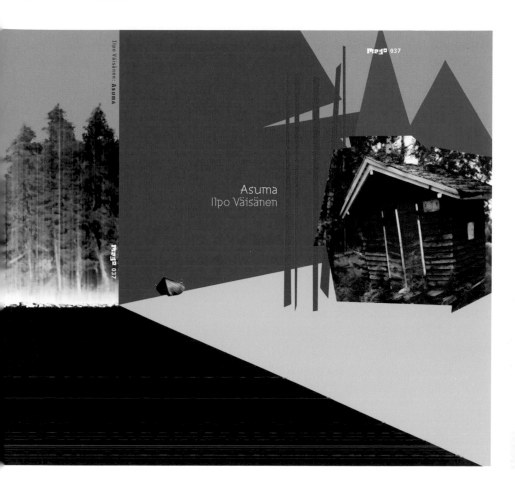

Fernando Gutiérrez

Fernando Gutiérrez Pentagram Ltd., 11 Needham Road, London W11 2RP, UK
T +44 20 7229 3477 F +44 20 7727 9932 E email@pentagram.co.uk www.pentagram.co.uk

"It all begins with an idea (ideas make money: money doesn't make ideas) and you respond to that idea, using your knowledge to present it in the most seductive, engaging manner possible."

"There are more design students and more designers than ever. There are more magazines than ever. More access to information than ever. And more information to decipher than ever. Craft and vocation are being left behind. Good design will prevail, but the amount of bad design is overwhelming. We shouldn't be misled. The struggle continues."

» Es gibt heute mehr Grafikstudenten und Grafiker als je zuvor. Mehr Zeitschriften als je zuvor. Leichteren Zugang zu Informationen als je zuvor. Und mehr zu entschlüsselnde Informationen als je zuvor. Handwerk und Berufung werden vernachlässigt. Gutes Design wird sich durchsetzen, aber die Menge von schlechtem Design ist überwältigend. Wir sollten uns nicht in die Irre führen lassen. Der Kampf geht weiter.«

« Il n'y a jamais eu autant de créateurs et d'étudiants graphistes. Il n'y a jamais eu autant de publications. Jamais l'information n'a été aussi accessible et il n'y a jamais eu autant d'informations à déchiffrer. L'artisanat et la vocation restent sur la touche. La bonne création perdurera mais on est submergé par des réalisations médiocres. Ne nous égarons pas. Le combat continue.»

Opposite page:

Project
Magazine cover design

Title
Matador Volume E

Client
Matador / La Fabrica

Year
2000

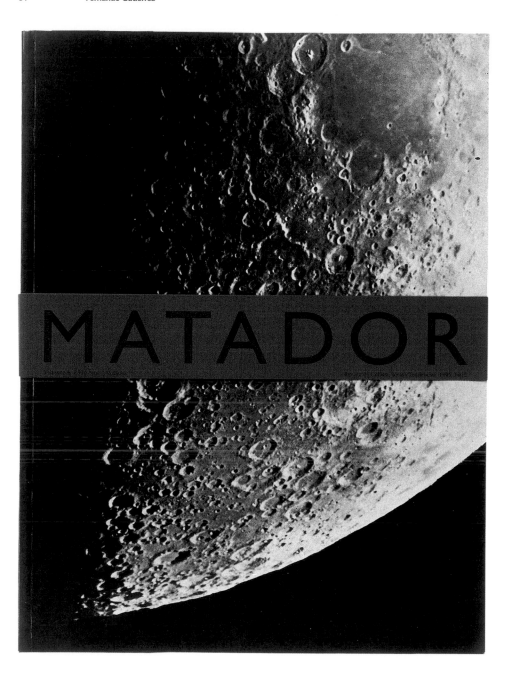

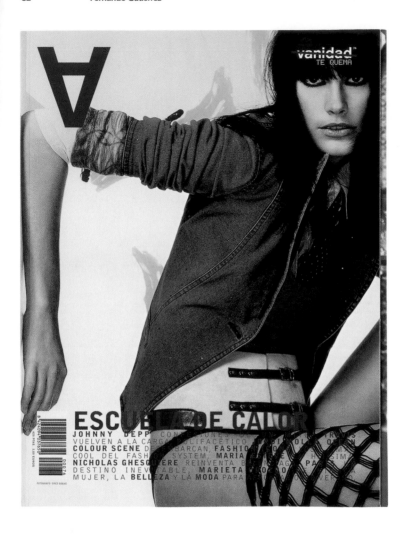

Project
Magazine cover design

Title
Vanidad

Client
Vanidad

Year
1998

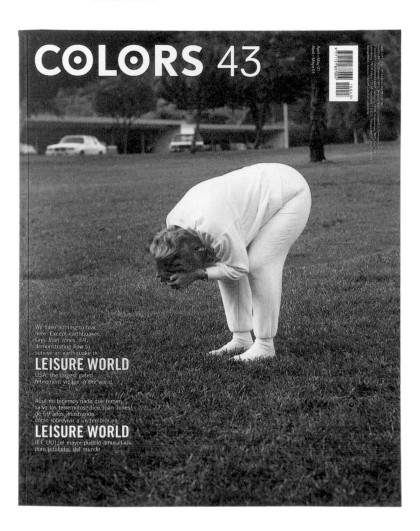

Project
Magazine cover design

Title
Colors – pictured: issue 43

Client
Benetton Group Spa /
La Fabrica

Year
2000–the present

Fons M. Hickmann

Fons M. Hickmann Fons Hickmann m23, Mariannenplatz 23, 10997 Berlin, Germany
T +49 30 6951 8501 F +49 30 6951 8511
E m23@fonshickmann.de E hickmann@fonshickmann.de www.fonshickmann.de

"Displace yourself!"

"Learn everything you can. Try everything that comes along. Look at everything there is to see. Search, experiment, make mistakes, fail, stand up. Turn religious, turn conservative, turn radical. And then forget all about it and find your own way to create."

»Lerne, was du kannst. Probiere aus, was du willst. Siehe, was es gibt. Suche, experimentiere, mache Fehler, steige auf Berge und gehe durch Täler. Werde fromm, werde verdorben, werde konservativ und werde radikal. Und dann vergiss all das und lerne, deinen eigenen Weg zu gestalten.«

«Apprends tout ce que tu peux. Essaye ce que tu veux. Vois ce qu'il y a à voir. Cherche, expérimente, fais des erreurs, échoue et reléve-toi. Deviens mystique, deviens dépravé, deviens conservateur et deviens radical. Et ensuite oublie tout cela et trouve ton propre chemin afin de créer.»

Opposite page:

Project
Magazine

Title
Der Architekt

Client
BDA

Year
2001

Der Architekt 225 **Verlust der Mitte**
September 2000
Zeitschrift des Bundes Deutscher Architekten BDA
Verlagsgesellschaft Rudolf Müller

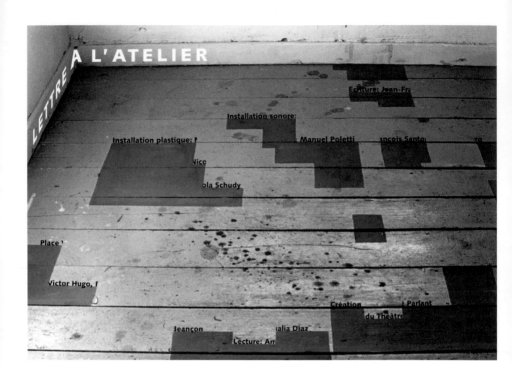

Opposite page:

Project
Poster

Project
Illustration

Title
Lettre à l'atelier

Title
Football is coming home

Client
Théâtre Parlant

Client
Page magazin

Year
1997

Year
2001

PAGE: 31 Jan 2001 13:35:08
...Die 10 Kreativsten der Kreativen laden wir ein, auf einer Seite der
Page das Thema Kreativitaet zu visualisieren.
Einsendeschluss: Dienstag, den 13.2.01 !!!

FONS: 31 Jan 2001 20:52:15
...aber warum denn so knapp? in der Zeit schaffe ich gerade mal einen
halben Topflappen zu häkeln...

PAGE: 01 Feb 2001 10:29:11
...halber Topflappen wär auch nicht schlecht...

FONS: 01 Feb 2001 12:16:10
na gut, gehe Wolle kaufen...

Hi-ReS!

Hi-ReS! 47 Great Eastern Street, London EC2A 3HP, UK
T +44 20 7684 3100 F +44 20 7684 3129 E info@hi-res.net www.hi-res.net

"Our philosophy is simple: never do a job you don't believe in. Do every job with as much enthusiasm as if it was your first and as much attention to detail as if it was your last."

"The future of design definitely doesn't lie in one discipline such as web design alone, for us it lies in the connection of design, architecture, the moving image, etc. The web doesn't allow for many things due to the limitations of the screen, the browser etc., but what it can do is to combine many different things and turn them into one and that's the strength of it. No picture on a site will ever be as impressive as a printout of the same design on A0. It's movement, interaction, the idea of being connected and sound that make the web special."

» Die Zukunft des Grafikdesigns liegt für uns definitiv nicht in einer Spezialisierung wie dem Webdesign allein, sondern in der Fusion von Grafik, Architektur, bewegten Bildern u. Ä. Aufgrund der Beschaffenheit von Bildschirm, Browser usw. bietet das Internet zwar nur begrenzte Möglichkeiten, man kann damit aber viele verschiedene Dinge zu etwas Ganzem kombinieren und genau das ist seine Stärke. Kein Bild auf einer Internetseite wird jemals so eindrucksvoll sein wie der Ausdruck des Bildes im Format A0. Es sind Bewegung, Interaktion, weltweite Verbindungen und Ton, die das Internet zu etwas Besonderem machen.«

« L'avenir du graphisme ne dépend pas que d'une seule discipline telle que l'infographie. Pour nous, il réside dans sa rencontre avec d'autres domaines tels que l'architecture, les images animées, etc. Le web ne permet pas de faire tout ce qu'on veut car il est limité par l'écran, le navigateur etc, mais il tient sa force du fait qu'il peut combiner de nombreux éléments différents et les transformer en un seul. Aucune image d'un site ne sera jamais aussi impressionnante que le tirage sur papier au format A0 du même graphisme. Ce sont le mouvement, l'interaction, l'idée d'être connecté et le son qui rendent le web spécial. »

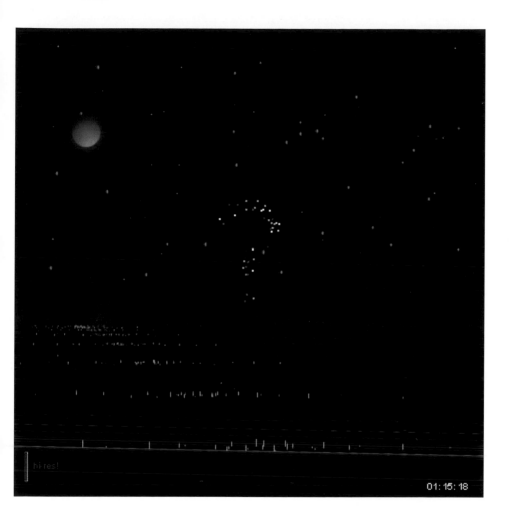

Project
Website
www.mindthebanner.com

Title
Mind The Banner

Client
NTT Data

Year
2001

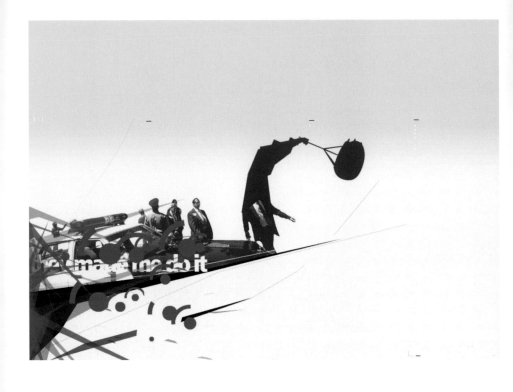

Opposite page:

Project
Website
www.donniedarko.com

Title
Donnie Darko

Client
Newmarket Films

Year
2001

Project
Website
www.donniedarko.com

Title
Donnie Darko

Client
Newmarket Films

Year
2001

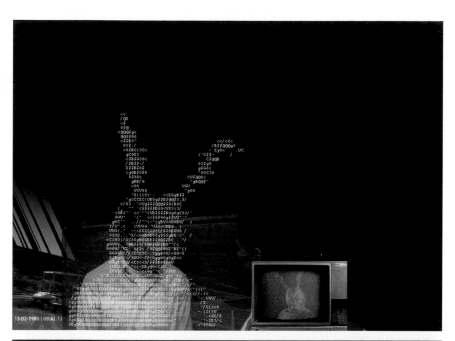

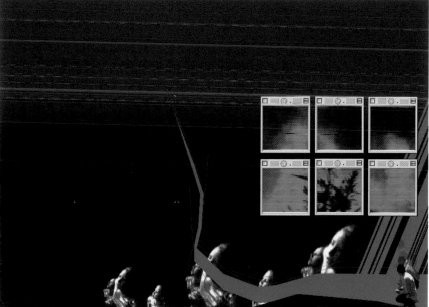

Angus Hyland

Angus Hyland Pentagram Design Ltd., 11 Needham Road, London W11 2RP, UK
T +44 20 7229 3477 F +44 20 7727 9932 E email@pentagram.co.uk www.pentagram.com

"Continental modernism meets British eclecticism."

"The discipline of graphic design will continue to evolve through technological and aesthetic advances, adapting to meet the needs of the market in an increasingly fashion-conscious world."

» Der Beruf des Grafikers wird sich infolge technischer und ästhetischer Fortschritte entwickeln und sich den Erfordernissen des Marktes in einer zunehmend modebewussten Welt anpassen. «

« Le graphisme continuera à évoluer au fil des progrès techniques et esthétiques, s'adaptant pour satisfaire les besoins du marché dans un monde de plus en plus axé sur la mode. »

Opposite page:

Project
Poster

Title
"No Picnic" exhibition

Client
Crafts Council

Year
1998

Crafts Council Gallery,
44a Pentonville Road,
Islington, London N1 9BY
Tel 0171 278 7700
5 minutes from
Angel tube

Free entry.
Tues to Sat 11-6,
Sun 2-6, Closed Mon
& Disabled Access

NO PICNIC

9.7.98–30.8.98

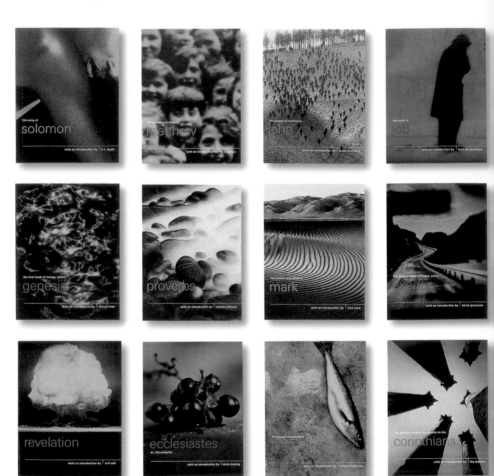

Project
Book design and packaging

Title
The Pocket Canon Bibles

Client
Canongate Books

Year
1998

Project
Book cover

Title
Dreamer by Charles Johnson

Client
Canongate Books

Year
1999

Project
Book cover

Title
Scar Culture by Toni Davidson

Client
Canongate Books

Year
1999

Hideki Inaba

Hideki Inaba Hideki Inaba Design, PK108 2–32–13 Matsubara Setagaya-ku, Tokyo 156–0043, Japan
T +81 3 3321 1766 F +81 3 3321 1766 E inaba@t3.rim.or.jp

"Thinking is very difficult and very easy."

" Either everything will be called design or nothing will be called design. The public will decide the direction of design."

» Entweder wird alles als Design bezeichnet werden oder nichts. Die Öffentlichkeit wird die Richtung bestimmen, die das Grafikdesign einschlägt.«

« Soit tout sera appelé design soit rien ne sera appelé design. Le public décidera de l'orientation du graphisme.»

Opposite page:

Project
Magazine cover

Title
SAL magazine.
Vol. 003 cover art

Client
SAL

Year
2001

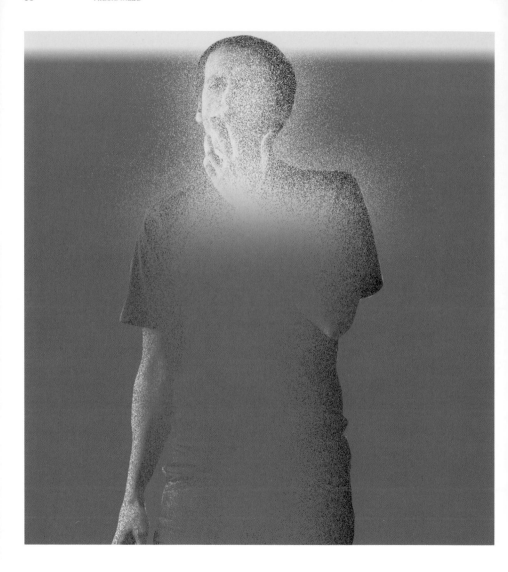

Opposite page:

Project
Magazine

Title
Artwork from "+81" magazine

Client
+81

Year
2000

Project
Magazine covers

Title
"+81" magazine
vol. 10
vol. 11

Client
+81

Year
2000–2001

Inkahoots

Inkahoots 239 Boundary Street, West End, Queensland 4101, Australia
T +61 7 3255 0800 F +61 7 3255 0801 E mail@inkahoots.com.au www.inkahoots.com.au

"Direct Design Action!"

" Like the child that closes its eyes and imagines it can't be seen, design now seems wilfully blinded to the anti-human consequences of consumer capitalism. We release rushing torrents of words, images and sounds that often say nothing at all, and at worst deceive and degrade our humanity. We also create electric work with the potential to explore new ways of knowing ourselves. Inkahoots believes our visual language is a site for the organisation of social power. We can close our eyes and pretend the world isn't there, or we can begin to imagine a better world."

» Wie das Kind, das sich vorstellt, dass man es nicht mehr sehen kann, wenn es seine Augen geschlossen hat, so scheint Design im Augenblick willentlich blind zu sein für die Konsequenzen des Konsumkapitalismus. Wir veröffentlichen reißende Ströme von Wörtern, Bildern und Klängen, die oft nichts sagen und im schlimmsten Fall unsere Menschlichkeit täuschen und degradieren. Wir schaffen auch elektrische Arbeit, die uns neue Möglichkeiten bietet, uns selbst kennen zu lernen. Inkahoots glaubt, dass unsere visuelle Sprache ein Ort ist, an dem soziale Macht organisiert werden kann. Wir können unsere Augen schließen und so tun, als ob die Welt nicht da sei. Oder wir können uns eine bessere Welt vorstellen.«

« Comme l'enfant qui, en fermant les yeux, imagine qu'il est devenu invisible, la création semble s'être délibérément mis des œillères pour ne pas voir les conséquences de la consommation capitaliste. Nous déversons des torrents de mots, d'images et de sons qui ne veulent souvent rien dire et qui, dans le pire des cas, trompent et dénaturent notre humanité. Nous réalisons également du travail dynamique qui pourrait nous permettre d'explorer de nouvelles manières de nous connaître nous-mêmes. A Inkahoots, on estime que notre langage visuel constitue un espace où organiser le pouvoir social. Nous pouvons fermer les yeux et faire semblant que le monde n'est pas là, ou nous pouvons imaginer un monde meilleur. »

Opposite page:

Project
Street poster

Title
Business is Booming –
Blockade the Stock Exchange

Client
M1 Alliance

Year
2001

M1 : 01/05/01 : 7AM
BLOCKADE **
THE STOCK EXCHANGE

CANCEL THIRD WORLD DEBT

ABOLISH THE WORLD BANK, IMF AND WTO

ECOLOGY BEFORE ECONOMY

OUR WORLD IS **NOT FOR SALE**

BUSINESS IS
BOOMING

capitalism blows me away

BLOCKADE: 7AM TUESDAY 1ST MAY 2001, AUSTRALIAN STOCK EXCHANGE, 123 EAGLE ST, BRISBANE.
CONTACT: EMAIL M1BRIS-SUBSCRIBE@YAHOOGROUPS.COM; PHONE 3831 2644; WEB WWW.M1BRISBANE.IWARP.COM

DESIGN + inkahoots

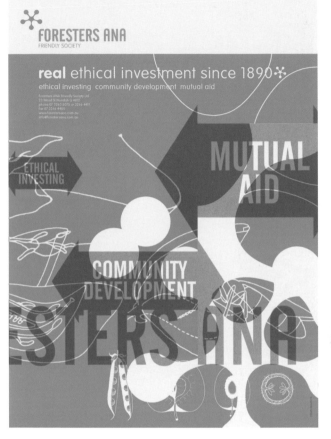

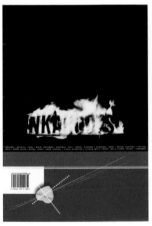

Project
Visual identity /
promotional poster

Title
Foresters ANA Friendly Society

Client
Foresters ANA Friendly Society

Year
2002

Project
Promotional book

Title
Public x Private

Client
Self-published

Year
2000

Opposite page:

Project
Protest poster

Title
No Vacancy – Evicting the Homeless

Client
West End Community House

Year
2001

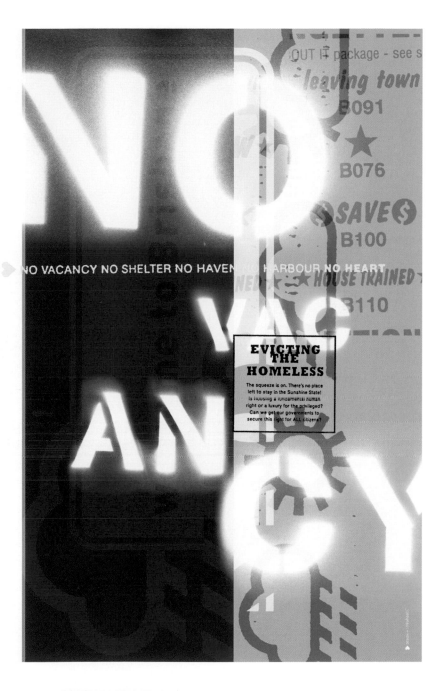

Intro

Intro 35 Little Russell Street, London WC1A 2HH, UK
T +44 20 7637 1231 F +44 20 7636 5015 E jo@intro-uk.com www.introwebsite.com

"Aesthetics first"

"The increasing use of graphic design as a purely commercial tool is devaluing its currency. The big design groups, and the big buyers of design, talk about 'difference', but they really mean sameness: everything looks the same. Design has been supplanted by branding, but no member of the public ever said: look at that branding! It means that design is becoming a visual sandwich-spread, and the result is blandness, uniformity and timidity. And paradoxically this is being done at a time when interest in visual culture has reached a high-point."

» Die Tatsache, dass die Gebrauchs-grafik in zunehmendem Maße ausschließlich zur Werbung eingesetzt wird, wertet sie ab. Die großen Designbüros und die großen Auftraggeber sprechen von ›Unterschied‹, meinen in Wirklichkeit aber ›Gleichheit‹: Alles sieht gleich aus. Design ist durch Markenbildung ersetzt worden, aber keiner würde sagen: ›Guck dir mal diese Markenbildung an!‹ Das bedeutet, dass die grafische Gestaltung zum visuellen Brot-aufstrich geworden ist, und das Resultat sind Reizlosigkeit, Uniformität und Ängstlichkeit. Para-doxerweise geschieht das zu einer Zeit, in der das Interesse an der visuellen Kultur einen Höhepunkt erreicht hat.«

« Le recours croissant au graphisme comme un outil purement commercial le dévalue. Les grands bureaux et les grands acheteurs de graphisme parlent de ‹ différence › mais il faut plutôt comprendre ‹ uniformité › : tout se ressemble. Le design a été supplanté par la stratégie de marque mais personne dans la rue ne s'est jamais écrié ‹ Oh, regarde cette stratégie de marque ! ›. Cela signifie que la création graphique est en train de devenir une pâte à tartiner visuelle. Le résultat est monotone, neutre et timoré. Paradoxalement, cela se produit à une époque où l'on s'est rarement autant intéressé à la culture visuelle. »

Opposite page:

Project
Poster

Title
Howie B - Folk

Client
Polydor

Year
2001

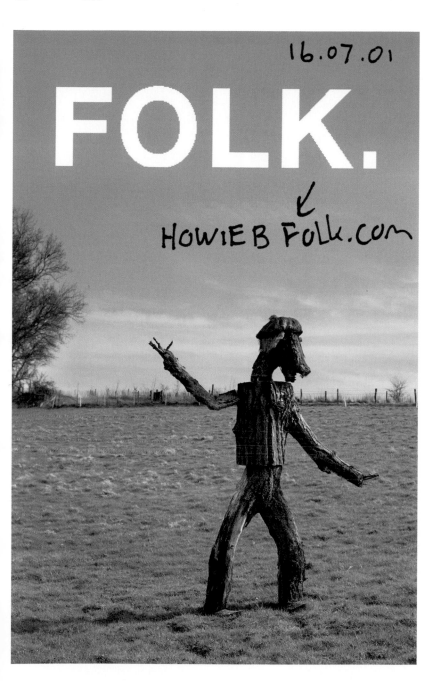

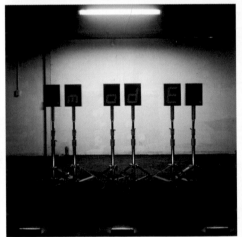

Project
Record covers

Title
Depeche Mode – singles 1986–98

Client
Mute

Year
1998

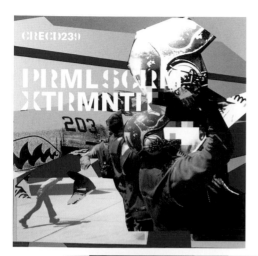

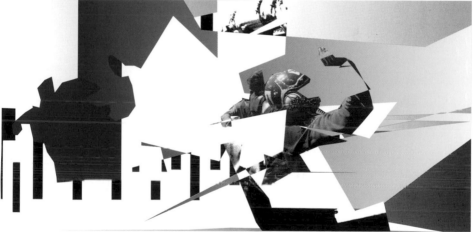

Project
CD booklet

Title
Primal Scream – Exterminator

Client
Creation

Year
2000

KesselsKramer

KesselsKramer Lauriergracht 39, 1016 RG Amsterdam, The Netherlands
T/F +31 20 530 1060 E church@kesselskramer.nl

"What is graphic design?"

" Graphic design is dead. It has been killed by computers with super-high speed chips, gigabyte overload and things called fire-wires. Don't worry. What matters today is not to execute, to kern, or to crop. The idea is the high-chieftain, the lord of the manor. A 'graphic designer' might want to make a film. Send a letter. Or even make a laser sculpture in the shape of a handbag. So be it! Now the real fun begins …"

» Die Gebrauchsgrafik ist tot. Ihre Mörder sind Computer mit ultra-hochleistungsfähigen Chips, mas-senhaft Gigabytes und Fire Wires genannten, blitzschnellen Verbin-dungen. Keine Sorge. Was heute zählt, ist nicht die Ausführung, das Unterschneiden oder Beschnei-den. Die Idee ist der Häuptling, der Herr der Dinge. Ein ›Grafik-designer‹ will vielleicht einen Film machen, einen Brief schreiben oder gar eine Laserskulptur in Form einer Handtasche schaffen. So sei es! Jetzt beginnt das eigent-liche Vergnügen …«

« Le graphisme est mort. Il a été tué par les ordinateurs, les puces ultra rapides, les surcharges de giga-octets et des machins appelés des ‹firewires›. Pas de panique. L'important aujourd'hui n'est pas d'exécuter, de créner, de rogner. L'idée est d'être le grand chef, le seigneur du château. Un ‹créateur graphique› peut décider de tour-ner un film, d'envoyer une lettre, ou même de réaliser une sculpture au laser en forme de sac à main. Ainsi soit-il! La fête ne fait que commencer…»

Opposite page:

Project
Smartlappen (tearjerker) Festival campaign

Title
I only cry at Smartlappen

Client
Smartlappen Festival

Year
2001

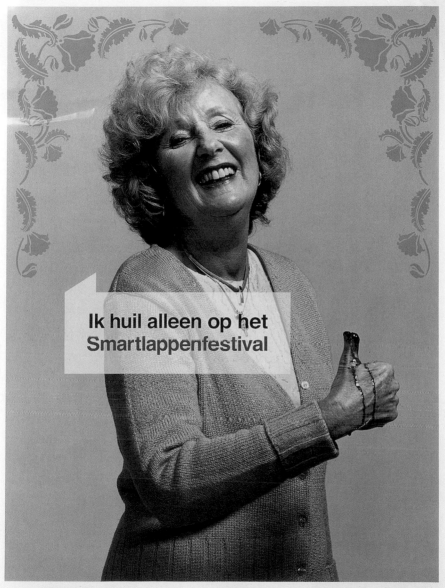

Ik huil alleen op het
Smartlappenfestival

UTRECHT 16-18 NOV 2001

toegang gratis – www.smartlappenfestival.nl

Project
Brochure for hotel

Title
Just Like Home

Client
Hans Brinker
Budget Hotel

Year
2001

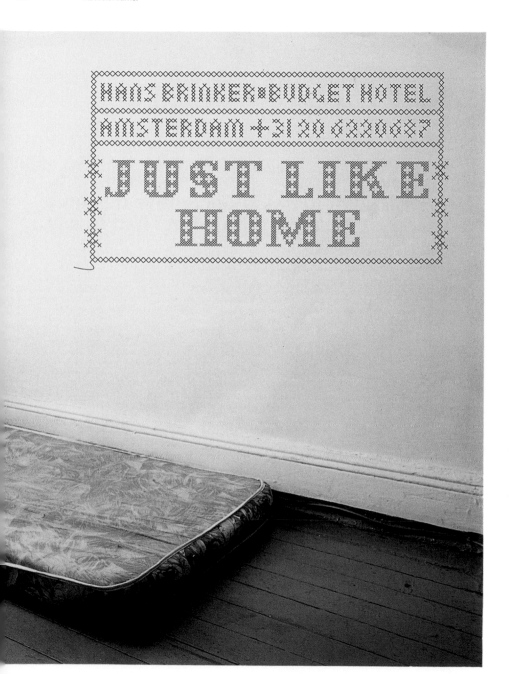

Scott King

Scott King 35 Baker's Hill, London E5 9HL, UK
T +44 20 8806 8336 E info@scottkingltd.com www.scottkingltd.com

"There's no point in doing decorative design... it would just interfere with what I had to say..."

"For me the worth of graphic design is its role in heightened moments of popular culture, the times when graphic design has contributed to inflicting change on society at large (Wyndham Lewis' 'Blast', Paris '68, British Punk ...). I approach all my projects from the point of view that they are potentially a vehicle that can comment on different aspects of society, while making work that is visually exciting."

» Für mich liegt der Wert der Gebrauchsgrafik in der Rolle, die sie in Hochzeiten der populären Kultur spielt, Zeiten, in denen sie zu allgemeinen gesellschaftlichen Veränderungen beigetragen hat (z. B. Wyndham Lewis' ›Blast‹, Paris 1968, oder die britische Punkbewegung). Ich gehe bei allen meinen Projekten davon aus, dass sie potenziell ein Vehikel für einen Kommentar zu verschiedenen gesellschaftlichen Phänomenen darstellen. Dabei versuche ich, optisch ansprechende Arbeiten zu produzieren.«

« Pour moi, la valeur du graphisme réside dans son rôle lors des moments forts de la culture populaire, lorsqu'il contribue à apporter du changement dans la société dans son ensemble (‹ Blast › de Wyndham Lewis, Paris en mai 68, le punk britannique). J'aborde chacun de mes projets comme s'ils avaient le potentiel de commenter différents aspects de la société, tout en réalisant un travail qui soit visuellement excitant. »

Opposite page:

Project
Poster

Title
Joy Division, 2 May 1980, High Hall, The University of Birmingham, England

Client
Self-published

Year
1999

Joy Division, 2 May 1980, High Hall, The University of Birmingham, England

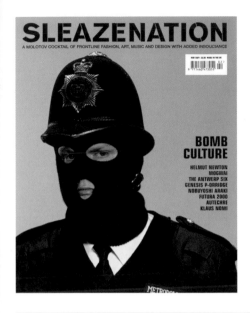

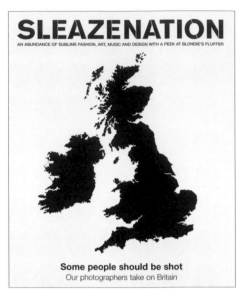

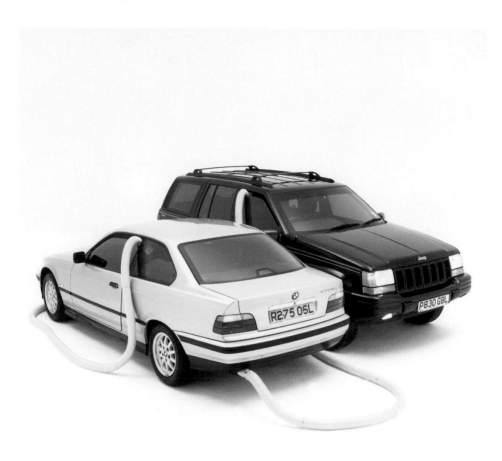

Opposite page:

Project
Magazine

Title
Sleazenation

Client
Sleazenation

Year
2001

Project
CD artwork for Earls Brutus album "Tonight
You are the Special One"

Title
I've got a Window Wednesday

Client
Island Records

Year
1998

Designbureau KM7 Schifferstrasse 22, 60594 Frankfurt/Main, Germany
T +49 69 9621 8130 F +49 69 9621 8122 E mai@km7.de www.km7.de

"Fight for optical pleasure!"

"Moving in a world in which reality is becoming more and more a subject to the media, in which MTV-isions dominate and transform our personal way of seeing things, in a world where the media are pushing forward an obfuscation of regionality, I simply want to underline the importance of reaching back to your gut feeling. Create, don't imitate!"

» In einer Welt, in der die Realität immer mehr von den Medien gezeichnet wird, die MTVisierung unsere Sicht der Dinge bestimmt und regionale Grenzen verschwinden lässt, empfinde ich persönlich es als besonders wichtig, auf sein eigenes, aus-dem-Bauch-heraus-Gefühl zu vertrauen. Create, don't imitate!«

« Evoluant dans un monde où la réalité est de plus en plus assujettie aux médias, où les MTV-isations dominent et transforment nos manières individuelles de voir les choses, où les médias favorisent l'obscurcissement des caractères régionaux, je tiens simplement à souligner l'importance de se fier à son instinct. Créez, n'imitez pas!»

Opposite page:

Project
Magazine spread for the issue 'mafia'

Title
Mafia-Style

Client
Styleguide Magazine

Year
2001

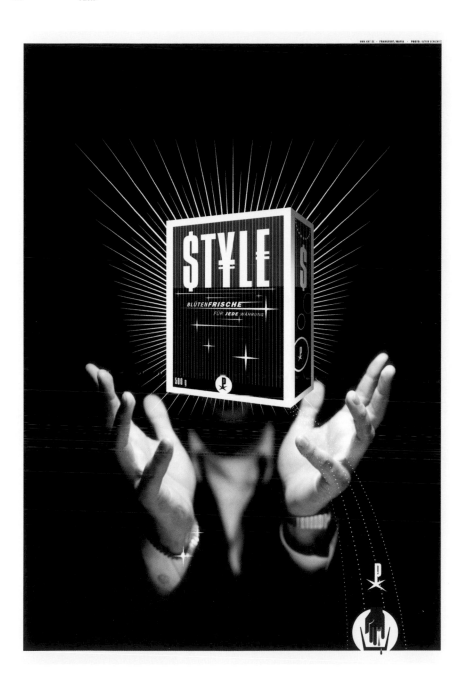

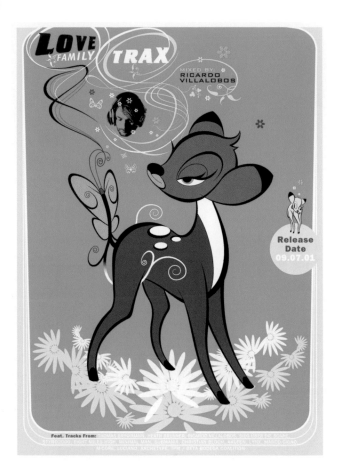

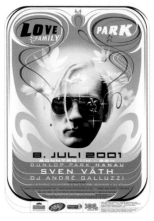

Project
Poster for the compilation "Love Family
Trax"
Poster for the event "Love Family Park"

Title
Love Family Park

Client
Fedi Chourkair

Year
2001

Opposite page:

Project
Album cover for the band "Tokyo Ghetto
Pussy"

Title
Disco 2001

Client
Sony Music Entertainment

Year
1997

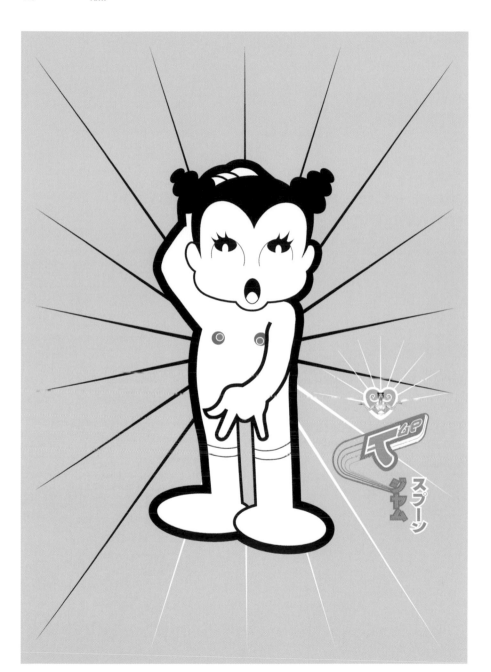

Christian Küsters

Christian Küsters CHK Design, 21 Denmark Street, London WC2H 8NA, UK
T +44 20 7836 2007 F +44 20 7836 2112
E christian@chkdesign.demon.co.uk www.acmefonts.net www.restartinteractive.co.uk

"Context + Concept + Collaboration >> Communication"

"In the future I think that Graphic Design will become more varied, fragmented and ultimately more specialised. From early on in their careers visual communicators will have to choose their area of specialisation. On the one hand it means that it will become increasingly difficult for the individual designer to work successfully across different disciplines within the field of visual communication. Those disciplines can range from font design to photography and digital retouching, over to animation and feature film and might consequently manifest itself in print, digital media or film. On the other hand, this development inevitably opens up more possibilities for various kinds of collaborations. And from my point of view that's where I think the future is; an interesting collaboration between individuals which at its best creates inspiring work."

» Ich glaube, dass Grafikdesign in der Zukunft variantenreicher, fragmentierter und letztendlich spezialisierter sein wird. Schon früh in ihrer Karriere werden Designer sich aussuchen müssen, auf welchen Bereich sie sich spezialisieren wollen. Einerseits bedeutet das, dass es immer schwieriger für den einzelnen Designer werden wird, in vielen Disziplinen der visuellen Kommunikation tätig zu werden, zu denen von Font-Design, Fotografie und digitaler Bildbearbeitung über Animationen und Feature-Filme alles bis zu Print- und digitalen Medien sowie Film gehören kann. Auf der anderen Seite eröffnet die Entwicklung neue Optionen für alle möglichen Kooperationen. Und von meinem Standpunkt aus sieht die Zukunft genau so aus: eine interessante Zusammenarbeit zwischen Individuen, die im besten Fall inspirierende Arbeiten hervorbringt.«

« A l'avenir, je pense que le graphisme sera plus varié, plus fragmenté et, finalement, plus spécialisé. Dès le début de leur carrière, les communicateurs visuels devront choisir leur spécialité. D'un côté, cela signifie qu'il sera de plus en plus difficile pour le graphiste individuel de naviguer librement d'une discipline à l'autre au sein de la communication visuelle. Ces disciplines iront de la conception de polices de caractère, de la photographie et des retouches numériques aux films d'animation ou de fiction, et pourront donc se manifester sous forme de papier, de média numérique ou de film. D'un autre côté, cette évolution ouvrira inévitablement de nouvelles possibilités à différentes sortes de collaborations. A mon avis, c'est là que se situe l'avenir : dans une collaboration intéressante entre des individus qui, quand elle fonctionne bien, crée des travaux inspirants. »

Opposite page:

Project
Exhibition poster

Title
Superstructure

Client
Museum für Gegenwartskunst, Zurich

Year
1998

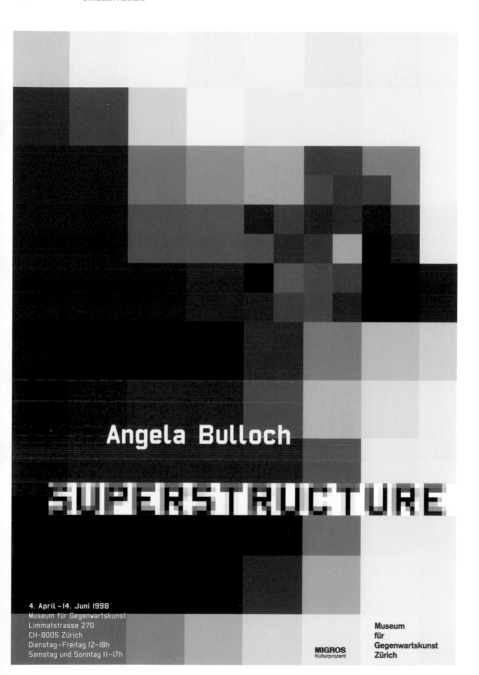

Project
Fashion catalogue

Title
Pearl in a Battlefield

Client
Fashion label "justMariOt"

Year
2001

M.A.D.

M.A.D. 237 San Carlos Ave, Sausalito, CA 94965, USA
T +1 415 331 1023 F +1 415 331 1034 E erik@madxs.com www.madxs.com

"Design is an alternative to ignorance and misconception."

"Graphic design has certainly been one of the faster changing professions in the last decade, but like all other design disciplines it is a part of today's global crisis. We have always designed for the future: in hope of increased pleasure, comfort, power, efficiency and return on investment. This time around we must design because of the past. We must counter a legacy of designs that left us with too much clutter, misinformation, pollution and dangerous inventions. We have progressively learnt to adapt to a world of increased acceleration and complexity. It is now time for the designed world to adapt back to humanity and for us to bring solutions of slowness and simplicity. Innovation should be defined not by novelty, but by sustainability."

» Die Tätigkeit des Grafikers gehört sicher zu den Berufen, die sich im letzten Jahrzehnt am schnellsten verändert haben, aber wie andere gestalterische Berufe auch ist er an der heutigen weltweiten Krise beteiligt. Wir haben immer für die Zukunft entworfen, in der Hoffnung auf mehr Vergnügen, Komfort, Macht, Effizienz und Rendite. Jetzt müssen wir wegen der Vergangenheit gestalten. Wir müssen der Hinterlassenschaft eines Designs entgegentreten, das uns zu viel Unordnung, Desinformation, Umweltverschmutzung und gefährliche Erfindungen beschert hat. Wir haben gelernt, uns einer sich immer schneller drehenden und immer komplizierteren Welt anzupassen. Jetzt muss sich die gestaltete Welt wieder der Menschheit anpassen und es ist an den Designern, langsamere, einfachere Lösungen zu entwickeln. Innovation sollte nicht als Neuheit, sondern als Nachhaltigkeit definiert werden.«

« Le graphisme est certainement l'une des professions qui a le plus changé au cours de la dernière décennie mais, comme toutes les autres disciplines du design, il participe à la crise mondiale actuelle. Nous avons toujours travaillé pour l'avenir dans l'espoir d'augmenter le plaisir, le confort, le pouvoir, l'efficacité, la rentabilité. Cette fois, nous devons œuvrer en songeant au passé. Nous devons contrer un patrimoine encombré de graphismes, de fausses informations, de pollutions et d'inventions dangereuses. Nous avons progressivement appris à nous adapter à un monde toujours plus rapide et complexe. Il est temps de nous réadapter à l'humanité et d'apporter des solutions de lenteur et de simplicité. L'innovation ne devrait pas être étayée par la nouveauté mais par la viabilité. »

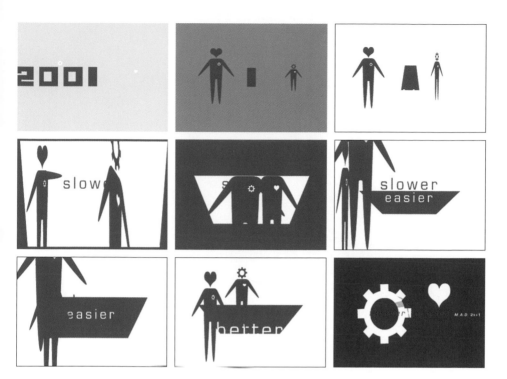

Project
Animated New Year's card

Title
2001

Client
ONE magazine / DIFFA [Design Industries
Foundation Fighting Aids]

Year
2001

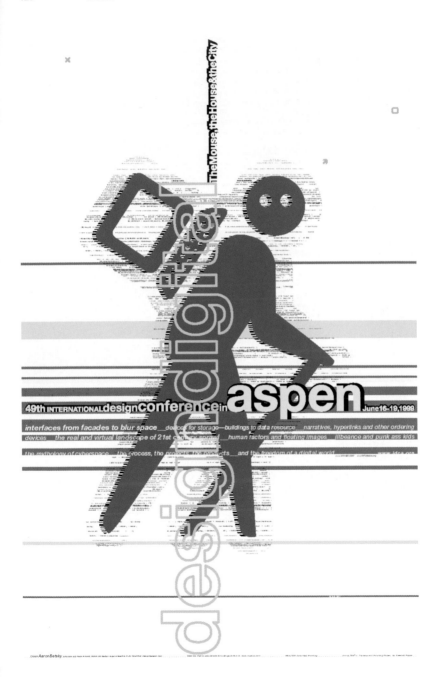

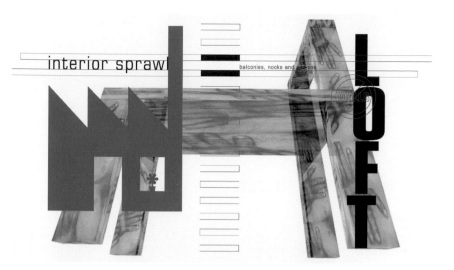

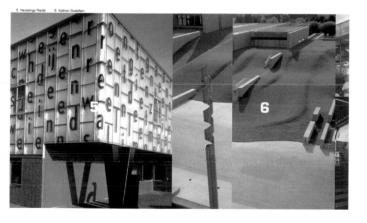

Opposite page:

Project
Poster

Title
Design.Digital: the mouse, the house,
the city

Client
International Design Conference in
Aspen

Year
1999

Project
Book spreads

Title
Architecture Must Burn, by Aaron Betsky
and Erik Adigard

Client
Thames & Hudson / Gingko Press

Year
2000

Me Company

ME Company 14 Apollo Studios, Charlton Kings Road, Kentish Town, London NW5 2SA, UK
T +44 20 7482 4262 F +44 20 7284 0402 E paul@mecompany.com www.mecompany.com

"Go further out and faster."

"The modern, technologically enhanced process of graphic design is already causing people to reconsider what the category means. It's branching out into so many new areas, drawing inspiration and knowledge as it goes. This blurring of conceptual and creative boundaries is vital to the development of the category."

» Der moderne, technisch vorangetriebene Prozess des grafischen Gestaltens gibt schon jetzt Anlass darüber nachzudenken, was Grafikdesign eigentlich bedeutet. Grafiker sind heute im Begriff, in viele neue kreative Bereiche vorzudringen und dabei ungewöhnliche Anregungen aufzunehmen und neues Wissen zu erwerben. Und gerade dieses Verwischen konzeptueller und gestalterischer Grenzen ist wesentlich für die Weiterentwicklung des Grafikdesigns.«

« Les procédés modernes de la création graphique, renforcés par la technologie, nous incitent déjà à revoir le sens de cette discipline. Elle étend ses ramifications dans un nombre croissant de nouveaux secteurs, puisant son inspiration et ses connaissances sur le tas. Ce flou croissant des frontières conceptuelles et créatives est vital pour l'évolution de ce domaine.»

Opposite page:

Project
Björk. Selmasongs

Title
Björk as Selma 1

Client
One Little Indian Records

Year
1999

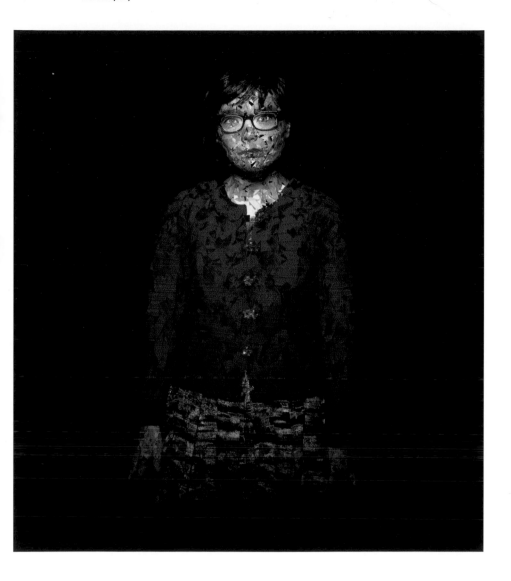

Project
Explorer

Title
Explorer 5.7 &
Explorer 4.2

Client
Self-published

Year
2001

Opposite page:

Project
Numero Orchids magazine artwork

Title
Coelogyne 2.1

Client
Numero Magazine

Year
2001

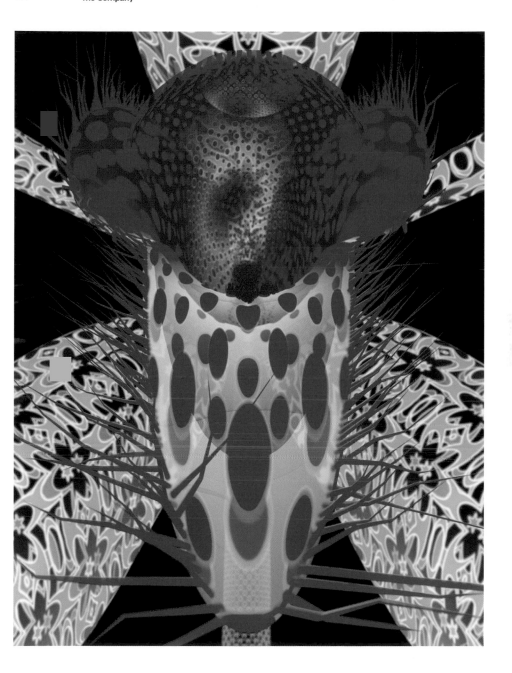

M/M (Paris)

M/M (Paris) 5–7, rue des Récollets, 75010 Paris, France
T +33 1 4036 1746 F +33 1 4036 1726 E anyone@mmparis.com www.mmparis.com

"It is almost by virtue of a logical development in the history of art that we have been called today to work in the field of design."

"An image never interests us as such. Its relevance lies in the fact that it contains the sum of preceding dialogues, stories, experiences with various interlocutors, and the fact that it induces a questioning of these pre-existing values. This is what makes for us a pertinent image. A good image should be in between two others, a previous one and another to come."

» Ein Bild ist nie an sich schon interessant. Seine Relevanz beruht darauf, dass es das Resultat vorhergegangener Gespräche, Geschichten und Erfahrungen verschiedener Menschen ist und es Fragen zu den in ihm ausgedrückten Werten provoziert. Das ergibt dann für uns ein treffendes Bild. Ein gutes Bild sollte zwischen zwei anderen stehen: einem früheren und einem späteren.«

« Une image en elle-même ne nous intéresse pas. Sa pertinence réside dans le fait qu'elle contienne la somme des dialogues, d'histoires et d'expériences antérieures avec divers interlocuteurs et qu'elle induise un questionnement des valeurs préexistantes. C'est ce qui nous la rend pertinente. Une bonne image devrait se situer entre deux autres, une précédente et une à venir. »

Opposite page:

Project
Generic poster for a series of art films, in collaboration with Pierre Huyghe & Philippe Parreno

Title
Ann Lee: No Ghost Just A Shell

Client
Anna Sanders Films

Year
2000

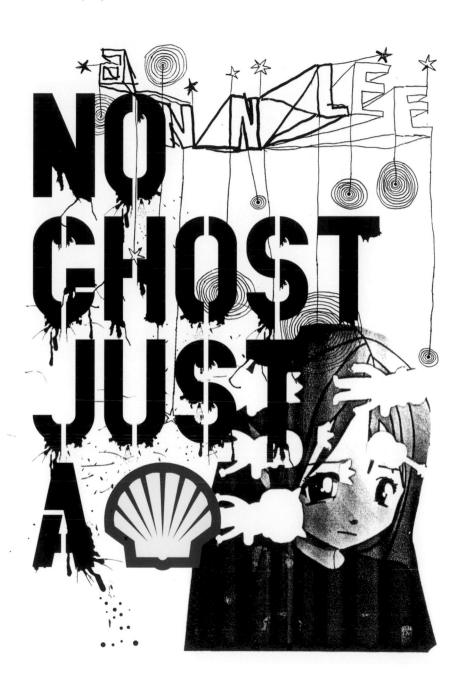

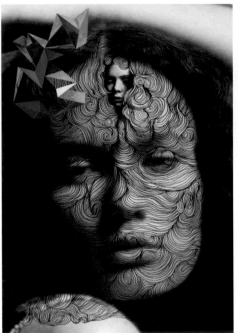 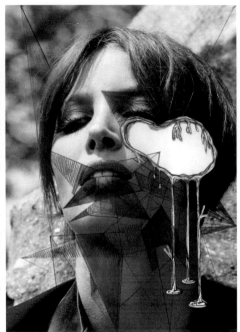

Opposite page:

Project
Theatre poster

Project
Invitation card for Balenciaga
Fall / Winter 2002/03 collection

Project
Invitation card for Balenciaga
Spring / Summer 2002 collection

Title
Marion de Lorme

Title
Balenciaga (Melia)

Title
Balenciaga (Christy)

Client
CDDB Théâtre de Lorient

Client
Balenciaga

Client
Balenciaga

Year
1999

Year
2002

Year
2002

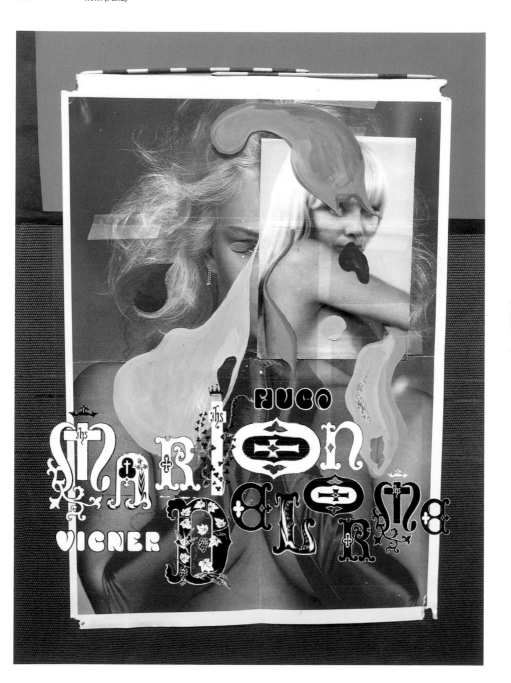

Mutabor

Mutabor Barnerstrasse 63 / Hof, 22765 Hamburg, Germany
T +49 40 399 224 21 F +49 40 399 224 29 E info@mutabor.de www.mutabor.de

"Mutabor Design is specialized in the evaluation of trends in terms of significance for product brand and media development – and in the translation of these trends into strategic design solutions."

" Society constantly deals with corporative directions and trends that have influence on its visual and linguistic habits. Graphic design constantly deals with the transformation of shapes, content and points of view. The future of graphic design means bringing all of this together and transposing it into strategic design solutions that are relevant to their audience."

» Unsere Gesellschaft beschäftigt sich fortwährend mit Trends und gesellschaftlichen Strömungen, die einen konstanten Einfluss auf unsere Seh- und Sprachgewohnheiten haben. Grafikdesign beschäftigt sich ständig mit der Veränderung von Formen, Inhalten und Sichtweisen. Die Zukunft des Grafikdesigns wird es sein, diese beiden Pole zu vereinen und in strategische Designlösungen umzusetzen, die für sein Publikum relevant sind.«

« La société absorbe en permanence des directives et des tendances dictées par les entreprises et celles-ci influent sur ses habitudes visuelles et linguistiques. La création graphique traite de la transformation des formes, des contenus et des points de vue. L'avenir du graphisme impliquera de les rassembler tous et de les transposer en solutions stratégiques qui aient un sens pour le public visé. »

Opposite page:

Project
Designers handbook

Title
Lingua Grafica

Client
Self-published

Year
2001

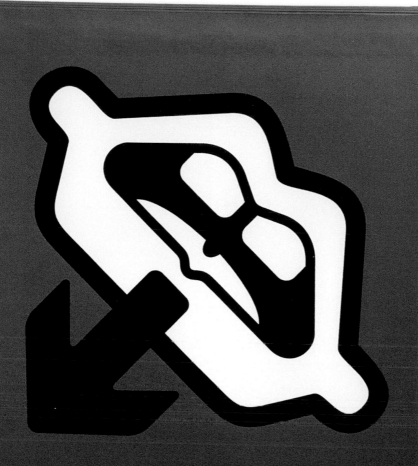

MUTABOR **lingua grafica** ➔ Großes Nachschlagewerk Bildsprache

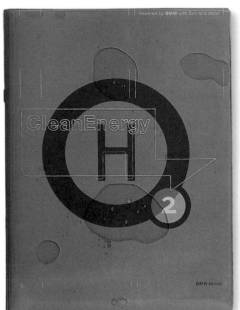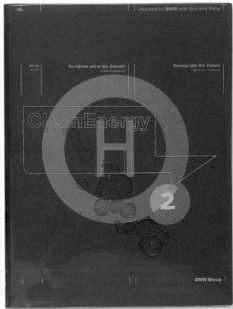

Project
Magazine/catalogue for BMW hydrogen
automobiles

Title
BMW Clean Energy Magalogues

Client
BMW

Year
2000

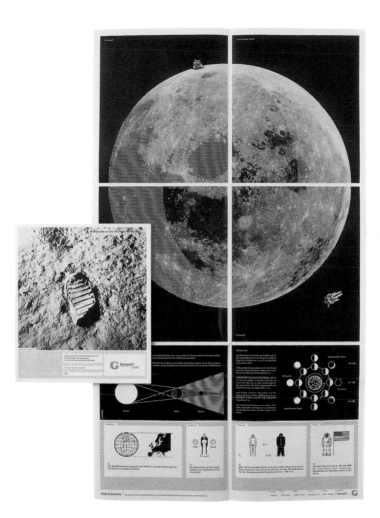

Project
Promotional mailing with poster for a gran-
ulated paper

Title
Classen Papier Granuprint Mailing

Client
Classen Papier, Essen

Year
2002

Martijn Oostra

Martijn Oostra Donker Curtiusstraat 25e, 1051 JM Amsterdam, The Netherlands
T +31 20 688 96 46 F +31 84 223 61 31 E info@oostra.org

"There are things that we usually do not see, do not look at. Sometimes you need someone to show you the beauty of these 'ugly' everyday things."

"The difference between various creative occupations will be less clear in the future. More often designers are seen to be editors and designers of magazines and books, or designer and artist at the same time. I work as a graphic designer, photographer, artist and publicist. My projects vary from video art to typography. There's a continuous thread in all my activities, whether it's a graphic design or an article, it's made with the 'tools' by which I communicate. I find my tools in the media or in public areas (the street). The reality is about reality. One shows how daily life is coded. What is banal in one context becomes meaningful in another. I'm always looking for beauty in triviality, but my work does have meaning, it's about what surrounds us. I look for the details that say as much as the whole and sometimes more. In the future designers will be communication specialists, working in diverse areas from art to advertising, from poetry to photography. The difference between the specialisations will be the 'tools' they use."

» Die Unterscheidung zwischen den verschiedenen kreativen Berufen wird in Zukunft undeutlicher werden. Immer öfter sind Grafikdesigner Redakteure und Gestalter von Zeitschriften und Büchern oder Designer und Künstler zugleich. Ich arbeite als Grafiker, Fotograf, Künstler und Publizist. Meine Arbeiten können zur Videokunst oder zur Typografie gehören. Der rote Faden, der sich durch alle meine Tätigkeiten zieht – ob grafisches Gestalten oder Artikel schreiben – sind die ›Werkzeuge‹, mit denen ich arbeite. Ich finde sie in den Massenmedien oder im öffentlichen Raum (auf der Straße). Bei der Realität geht es um Realität. Man zeigt, wie der Alltag verschlüsselt ist. Was im einen Kontext banal wirkt, ist in einem anderen bedeutungsvoll. Ich halte stets Ausschau nach Schönheit im Trivialen, aber meine Arbeiten haben auch inhaltliche Bedeutung, befassen sich mit dem, was uns täglich umgibt. Ich suche die Details, die ebenso viel aussagen wie das Ganze – und manchmal sogar mehr. In Zukunft werden wir Grafiker Kommunikationsspezialisten sein, die in verschiedenen Bereichen tätig sind: von Kunst bis Werbung, von Dichtung bis Fotografie. Unterscheiden werden sich die Spezialisierungen durch die verwendeten ›Werkzeuge‹.«

«A l'avenir, les différences entre les divers métiers de la création seront moins nettes. On voit de plus en plus les graphistes prendre le rôle de rédacteur et de concepteur de revues et de livres en même temps, ou comme étant à la fois créateurs et artistes. Je travaille en tant que graphiste, photographe, artiste et publicitaire. Mes projets vont de la vidéo artistique à la typographie. Il existe néanmoins un lien entre toutes mes activités: qu'il s'agisse d'une création graphique ou d'un article, elles sont réalisées avec les ‹outils› avec lesquels je communique. Je trouve ces outils dans les médias ou le domaine public (la rue). La réalité parle de la réalité. Il s'agit de révéler les codes de la vie quotidienne. Ce qui est banal dans un contexte prend tout son sens dans un autre. Je recherche toujours la beauté dans la futilité mais mon travail a un sens: il traite de ce qui nous entoure. Je traque les détails qui en disent aussi long qu'une vue d'ensemble, voire plus. A l'avenir, les créateurs deviendront des spécialistes de la communication, travaillant dans des domaines aussi variés que l'art et la publicité, la poésie et la photographie. La différence entre ces spécialisations sera les ‹outils› qu'elles requièrent.»

Project
Magazine submission

Title
Mutation

Client
Ad!dict, Brussels

Year
2001

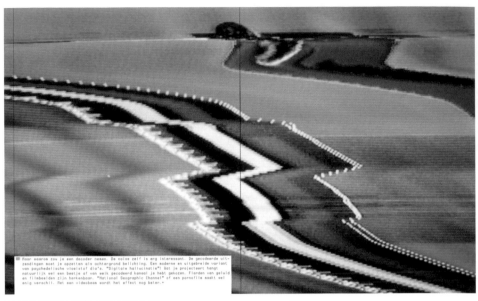

Opposite page:

Project
Television broadcast

Project
Millennium calendar project

Title
Digital Hallucination

Title
November 2000

Client
Credits (prepublication), Amsterdam /
Ad!dict, Brussels / PARK 4DTV, Amsterdam

Client
CDR Associates, Seoul

Year
1999–2002

Year
1999

Monday / Lundi / Montag / Lunedì / Maandag		- 6 NOV. 2000	1 3 NOV. 2000	2 0 NOV. 2000	2 7 NOV. 2000
Tuesday / Mardi / Dienstag / Martedì / Dinsdag		- 7 NOV. 2000	1 4 NOV. 2000	2 1 NOV. 2000	2 8 NOV. 2000
Wednesday / Mercredi / Mittwoch / Mercoledì / Woensdag	- 1 NOV. 2000	- 8 NOV. 2000	1 5 NOV. 2000	2 2 NOV. 2000	2 9 NOV. 2000
Thursday / Jeudi / Donnerstag / Giovedì / Donderdag	- 2 NOV. 2000	- 9 NOV. 2000	1 6 NOV. 2000	2 3 NOV. 2000	3 0 NOV. 2000
Friday / Vendredi / Freitag / Venerdì / Vrijdag	- 3 NOV. 2000	1 0 NOV. 2000	1 7 NOV. 2000	2 4 NOV. 2000	
Saturday / Samedi / Samstag / Sabato / Zaterdag	- 4 NOV. 2000	1 1 NOV. 2000	1 8 NOV. 2000	2 5 NOV. 2000	
Sunday / Dimanche / Sonntag / Domenica / Zondag	- 5 NOV. 2000	1 2 NOV. 2000	1 9 NOV. 2000	2 6 NOV. 2000	

Matt Owens

Matt Owens Volumeone, Suite 607, 54 West 21st Street, New York, NY 10010, USA
T +1 212 929 7828 E matt@volumeone.com www.one9ine.com www.volumeone.com

"An ongoing examination/conversation between the dynamics and interrelationships of personal exploration and professional practice."

"The definition of where graphic design ends and begins is becoming more and more blurred as technology and functional constraints begin to further determine visual constraints. As a result, I think that 'design' will become more clearly divided along visual and technological lines. I really enjoy the space between the visual and the technological and feel that designers who can negotiate the space between technology and aesthetics will be the most successful in the future. The interrelationship between print and interactive and motion graphics is an interesting space that will become more and more important in the future. Visual language exists all around us and this will not change. How visual language interacts with popular culture, technology and media/mediums will remain at the heart of what makes graphic design as a discipline so interesting and everevolving."

» Die Bestimmung der Punkte, an denen die Gebrauchsgrafik beginnt und endet, wird mit den durch Technik und funktionale Zwänge immer enger gezogenen optischbildlichen Grenzen zunehmend schwieriger. Meiner Meinung nach wird man ›Design‹ deshalb künftig noch klarer nach visuellen und technischen Kriterien kategorisieren. Mir macht das Spannungsfeld zwischen den visuellen Aspekten und der Technik Spaß und ich glaube, dass diejenigen Grafiker, denen die Verbindung von Technik und Ästhetik gelingt, in Zukunft am erfolgreichsten sein werden. Die Wechselbeziehung zwischen Druckgrafik und interaktiver Grafik mit bewegten Bildern stellt ein interessantes Feld dar, das in Zukunft an Bedeutung gewinnen wird. Wir sind auf allen Seiten von Bildsprachen umgeben und das wird auch so bleiben. Wie sie mit Popkultur, Technik und verschiedenen Medien interagieren, wird auch weiterhin den Kern des Grafikdesigns ausmachen, der es so interessant und entwicklungsfähig erhält.«

« La technologie et les restrictions fonctionnelles déterminant chaque fois plus les contraintes visuelles, on a de plus en plus de mal à définir où commence le graphisme et où il finit. Par conséquent, je pense que la ‹ création › sera plus clairement divisée par des frontières visuelles et technologiques. Je me plais bien dans l'espace contenu entre le visuel et le technologique et pense que les graphistes qui s'en sortiront le mieux seront ceux capables de négocier l'aire située entre la technologie et l'esthétique. Les interactions entre l'impression et le graphisme interactif et animé forment un domaine intéressant qui prendra de plus en plus d'importance. Le langage visuel est partout autour de nous et cela ne devrait pas changer. La manière dont il interagit avec la culture populaire, la technologie et les médias restera au cœur de ce qui fait du graphisme une discipline intéressante et en évolution constante.»

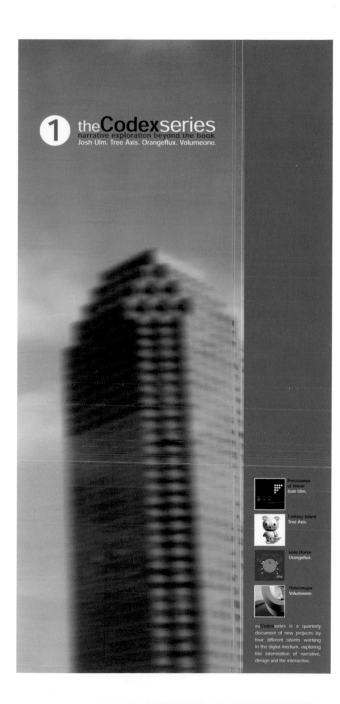

Project
CD Rom cover and poster

Title
CODEX SERIES 1 and 2

Client
Self-published

Year
1999/2000

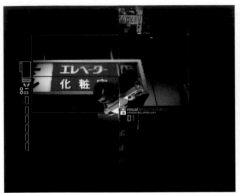
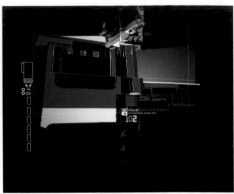
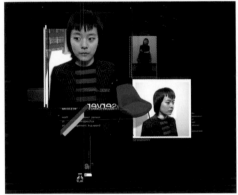
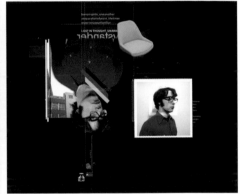

Opposite page:

Project
Website

Project
Emigre magazine spreads

Title
Volumeone, Spring 2001 (volumeone.com)

Title
Deep End

Client
Self-published

Client
Emigre Magazine 51

Year
1997–2001

Year
1999

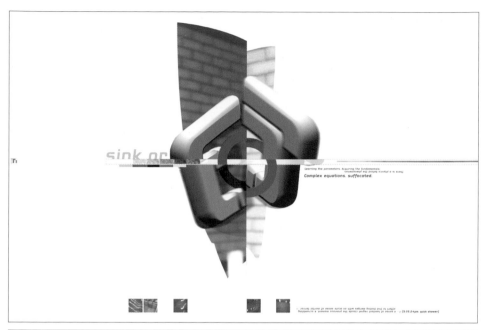

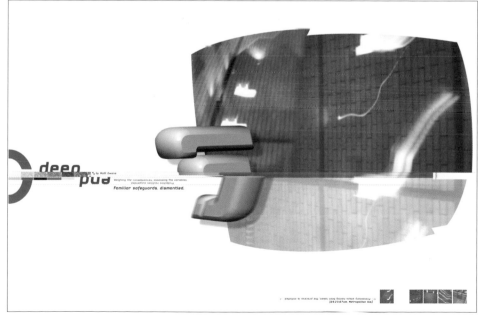

Mirco Pasqualini

Mirco Pasqualini Ootworld Srl, Piazza Serenissima, 40, 31033 Castelfranco Veneto (TV), Italy
T +39 042 342 5311 F +39 042 342 5312 E mirco.pasqualini@ootworld.com www.mircopasqualini.com

"I like design work because I can express my ideas and my thoughts. I can share my mind…"

"I'd like to create and build an entire city – I have been drawing buildings for a long time, I project streets, bridges, plazas; I'd like to create fashion; I'd like to create music; I'd like to cover the Chrysler Building in New York with images; I'd like to open a sunshine bar on a Caribbean beach; I'd like to follow important and creative projects for Human Interface research; I'd like to make drums, taking the wood and working it into an instrument; I'd like to travel for my business more weeks in a year; I'd like to live in Rovigo, in Paris, in New York, in Los Angeles, in Sydney and Tokyo; I'd like to learn every single creative technique; I'd like to have a son; I'd like all that means creativity. I'd like to dream forever ;-)"

» Ich würde gerne eine ganze Stadt entwerfen und bauen. Seit langem schon zeichne ich Gebäude, plane Straßen, Brücken und Plätze. Ich würde gerne Mode machen und Musik komponieren. Ich würde gerne das Chrysler Building in New York mit Bildern bedecken. Ich würde gerne eine Bar an einem Strand in der Karibik eröffnen. Ich würde gerne wichtige kreative Projekte im Bereich der Human Interface Forschung entwickeln. Ich würde gerne Trommeln herstellen, Holz nehmen und daraus ein Instrument bauen. Ich würde gerne jedes Jahr längere Geschäftsreisen als bisher machen. Ich würde gerne in Rovigo, in Paris, New York, Los Angeles, Sydney und Tokio leben. Ich würde gerne jede einzige kreative Technik erlernen. Ich hätte gerne einen Sohn. Ich hätte gerne alles, was Kreativität ausmacht. Ich würde gerne für immer und ewig träumen ;-)«

« J'aimerais créer et construire une ville entière. Je dessine des bâtiments depuis longtemps. J'imagine des rues, des ponts, des places. J'aimerais dessiner des vêtements. J'aimerais composer de la musique. J'aimerais recouvrir d'images le Chrysler Building à New York. J'aimerais ouvrir un bar paillote sur une plage des Caraïbes. J'aimerais suivre des projets importants et créatifs pour la recherche sur les interfaces ergonomiques. J'aimerais fabriquer des tambours, façonnant l'instrument à partir du bois brut. J'aimerais voyager plus souvent pour mon travail. J'aimerais vivre à Rovigo, à Paris, à New York, à Los Angeles, à Sydney et à Tokyo. J'aimerais apprendre toutes les techniques créatives. J'aimerais avoir un fils. J'aime tout ce qui signifie créativité. J'aimerais rêver toujours ;-)»

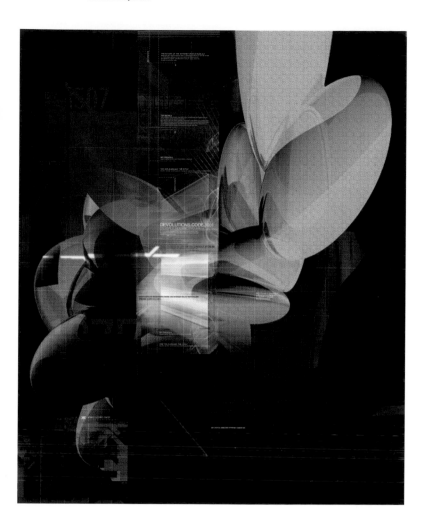

Project
Personal Book

Title
Graphic Design Experiment 5

Client
Self-published

Year
2002

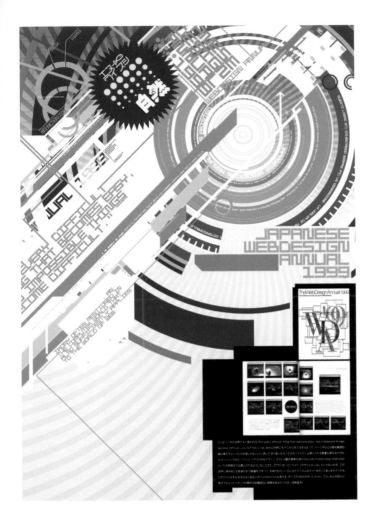

Opposite page, top:

Project
Personal book

Title
Teatro Massimo vision remix

Client
Self-published

Year
2001

Opposite page, bottom:

Project
Personal book

Title
FILA Skates vision remix

Client
FILA

Year
2001

Project
Personal book

Title
Japanese Web Design Annual 1999

Client
Self-published

Year
2000

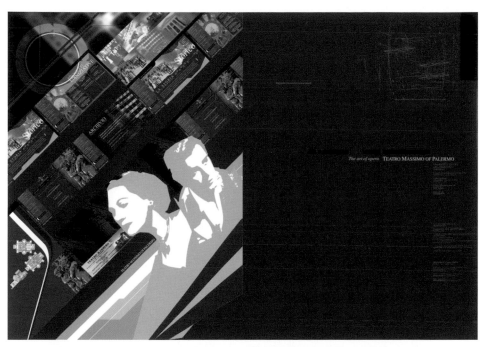

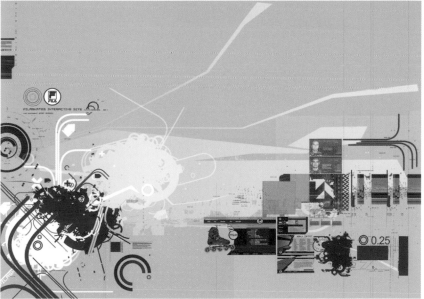

Research Studios

Research Studios 94 Islington High Street, Islington, London N1 8EG, UK
T +44 20 7704 2445 F +44 20 7704 2447 E info@researchstudios.com www.researchstudios.com

"Visual communication is soulfood for the mind."

"We operate across a broad range of commissions and media, from one-off creative projects to complete visual communication strategies. A small team infrastructure maintains a strong human aspect. For each project we work by creating solid systems and constructions over a well researched and rooted foundation or DNA. Over this solidity we then improvise, so as to explore new possibilities while remaining rooted in clear structure and code – a basic language model. Our approach to design is one of an exploratory process leading wherever we can to constantly evolving solutions focused on a criteria of revealing, not concealing, the underlying control mechanisms evident at the root level of visual communication. We attempt to actively engage the viewer emotionally and intellectually by confronting them with ambiguous and often incomplete or abstracted images, usually underpinned by a formal typography, which create a dialogue that by necessity can only be completed by the viewer's own interpretation, ensuring a fluidity of communication. This can help highlight directly the insubstantiality of consumer culture through a kind of experiential shift, and can often create a vital place of quiet, peace and oxygen."

» Wir bearbeiten eine breite Palette von Aufträgen und Medien, von kreativen Sonderlösungen bis hin zu kompletten visuellen Kommunikationsprogrammen. Aufgrund unserer Arbeitsweise in kleinen Teams bewahren unsere Entwürfe einen ausgeprägt menschlichen Aspekt. Jedes Projekt wird als ein stabiles System auf dem Fundament einer gründlich recherchierten Grundlage oder DNA entwickelt. Unser Gestaltungsansatz ist ein Erkundungsprozess, der uns zu sich stets entwickelnden Lösungen führt und sich darauf konzentriert, die Steuerungsmechanismen der visuellen Kommunikation aufzudecken statt zu verbergen. Wir bemühen uns, die Gefühle und den Verstand der Betrachter anzusprechen, indem wir ihnen zweideutige, vielfach auch unvollständige oder abstrahierte Bilder zeigen, begleitet von einer entsprechenden Typografie. Diese führt zu einem Dialog mit den Bildern, der nur von der Interpretation durch den Betrachter vervollständigt werden kann und so für eine fließende, unvorhersehbare Kommunikation sorgt. Das streicht – mithilfe einer Art Erfahrungsverschiebung – die Substanzlosigkeit der Konsumkultur heraus und ist oft dazu angetan, einen lebenswichtigen Ort der Stille, des Friedens und Luft zum Atmen zu schaffen.«

« Research Studios gère une vaste gamme de commandes et de moyens de communications, des projets créatifs isolés et des stratégies de communication visuelle complètes. Notre infrastructure en petites équipes nous permet de conserver un caractère très humain. Pour chaque projet, nous créons des systèmes et des constructions solides s'appuyant sur des fondations bien documentées. A partir de cet appui stable, nous improvisons, nous recherchons de nouvelles possibilités tout en restant enracinés dans un cadre et des codes clairs. Notre approche du graphisme repose sur l'exploration, sur une quête de solutions en évolution constante. Notre critère est de révéler, non de cacher, les mécanismes de contrôle sousjacents à la base de la communication visuelle. Nous tentons de faire intervenir les émotions et l'intellect du public en le confrontant à des images ambiguës, souvent incomplètes ou abstraites, généralement encadrées par une typographie formelle, créant un dialogue qui ne peut être complété que par l'interprétation personnelle de notre interlocuteur. Cela contribue parfois à souligner le caractère insaisissable de la culture de consommation et crée souvent un espace vital de tranquillité, de paix et d'oxygène. »

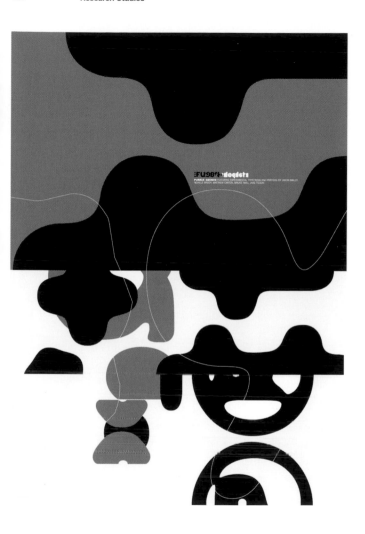

Project
Main promotional poster

Title
Fuse 18, Secrets

Client
Self-published

Year
2000

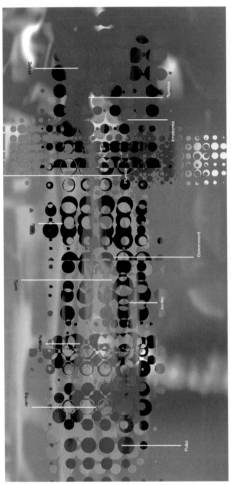
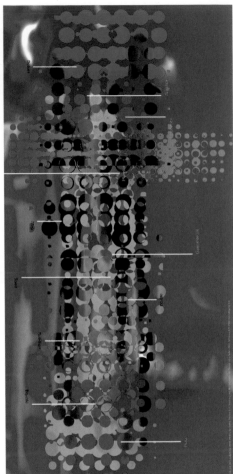

Project
Box edition of 'The Graphic Language of
Neville Brody', Books 1 and 2

Title
Special Poster Insert

Client
Thames and Hudson, London

Year
1994

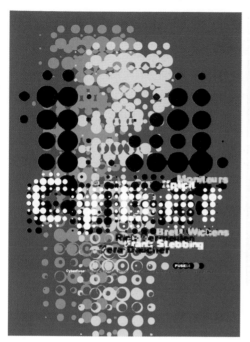

Project
Main promotional poster

Title
Fuse 14, Cyber

Client
FSI, Berlin

Year
1995

Project
Main promotional poster

Title
Fuse 15, Cities

Client
FSI, Berlin

Year
1996

Stefan Sagmeister

Stefan Sagmeister Sagmeister Inc., 222 West 14th Street, New York, NY 10011, USA
T +1 212 647 1789 F +1 212 647 1788 E Stefan@ Sagmeister.com www.sagmeister.com

"STYLE = FART"

"I am mostly concerned with design that has the ability to touch the viewer's heart. We see so much professionally done and well executed graphic design around us, beautifully illustrated and masterfully photographed, nevertheless, almost all of it leaves me (and I suspect many other viewers) cold. There is just so much fluff: well produced, tongue-in-cheek, pretty fluff. Nothing that moves you, nothing to think about, some is informing, but still all fluff. I think the main reason for all this fluff is that most designers don't believe in anything. We are not much into politics, or into religion, have no stand on any important issue. When your conscience is so flexible, how can you do strong design? I've seen movies that moved me, read books that changed my outlook on things and listened to numerous pieces of music that influenced my mood. Our goal for the future will be to touch somebody's heart with design."

» Mir geht es vor allem um Design, das dem Betrachter zu Herzen gehen kann. Wir sehen überall so viele professionelle Grafikarbeiten, die mich (und ich vermute auch viele andere Betrachter) kalt lassen. Es gibt so viele Schaumschläger, die technisch perfekten, hübschen Schaum produzieren. Nichts, das rührt oder zum Nachdenken anregt. Der Grund für all diese Schaumschlägerei ist, dass die Designer an nichts mehr glauben. Wir haben mit Politik nichts am Hut, mit Religion nicht, haben zu keiner wichtigen Frage einen eigenen Standpunkt. Wenn das Gewissen so wenig ausgeprägt ist, wie kann man dann überzeugendes Design schaffen? Ich habe Filme gesehen, die mich bewegt haben, Bücher gelesen, die meine Sicht der Dinge verändert, und Musikstücke gehört, die meine Stimmung beeinflusst haben. Unser Ziel muss es werden, mit unserem Design die Herzen zu berühren.«

«Je m'intéresse à un graphisme capable de toucher le cœur des gens. Nous voyons partout tant de créations graphiques bien réalisées, joliment illustrées, photographiées de main de maître. Pourtant, la plupart d'entre elles me laissent froid. C'est bien produit, ironique, agréable à regarder, mais ce n'est que du vent. Il n'y a rien qui vous émeuve, rien qui vous fasse réfléchir. Certaines vous informent, mais ça reste du vent. La plupart des créateurs ne croient en rien. Nous nous occupons peu de politique et de religion, nous ne prenons position sur aucune question importante. Avec une conscience aussi flexible, comment réaliser un graphisme fort? J'ai vu des films bouleversants, lu des livres qui ont changé ma vision des choses et écouté des morceaux de musique qui ont influencé mon humeur. A l'avenir, notre objectif sera de toucher le cœur d'un être humain avec notre graphisme.»

Opposite page:

Project
Lecture poster

Client
Cranbrook Academy of Art and AIGA
Detroit

Year
1999

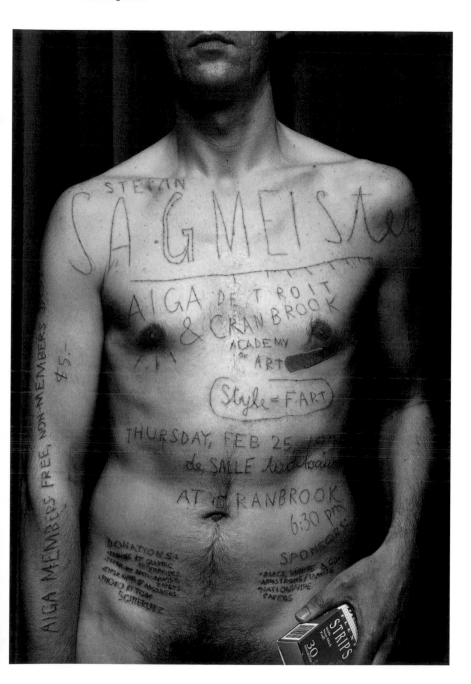

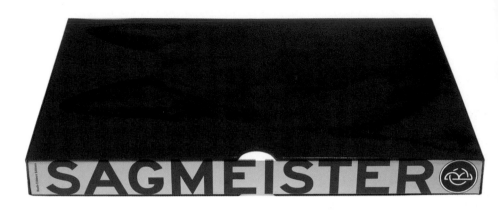

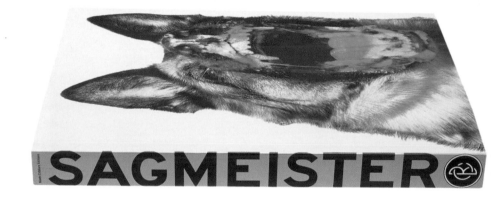

Project
Design monograph

Title
Made You Look

Client
Self-published

Year
2001

Opposite page:

Project
Poster

Title
Set the Twilight Reeling

Client
Warner Bros.

Year
1996

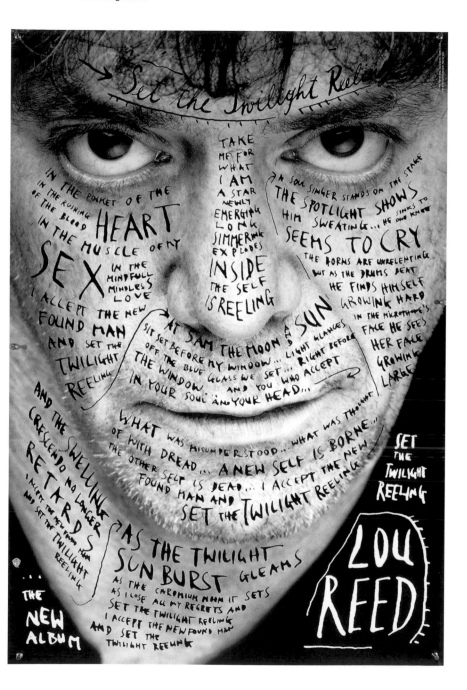

Peter Saville

Peter Saville Saville Associates, Expert House, 25–31 Ironmongers Row, London EC 1V 3QN, UK
T +44 20 7253 4334 F +44 20 7253 4366 E sarah@saville-associates.com

"Do your best."

" As the interface of today's social and cultural change, graphic design will continue to evolve as a reflection of the needs and values of its audience and its practitioners."

» Als Schnittstelle des derzeitigen sozialen und kulturellen Wandels wird das Grafikdesign sich als Reflexion der Bedürfnisse und Werte seines Publikums und seiner Schöpfer weiterentwickeln.«

« En tant qu'interface des changements sociaux et culturels contemporains, le graphisme continuera d'évoluer, reflet des besoins et des valeurs de son public et de ses exécutants. »

Opposite page:

Project
Illustration

Title
Waste Painting #3

Client
Graphic art Howard Wakefield, Peter Saville
& Paul Hetherington

Year
2002

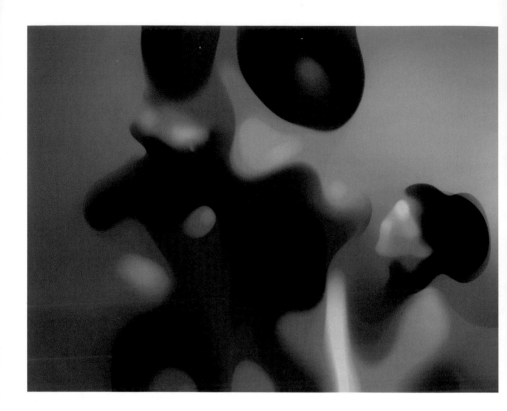

Project
Illustration. Graphic art Paul Hetherington &
Howard Wakefield

Title
Sister Honey

Client
Dazed & Confused

Year
1999

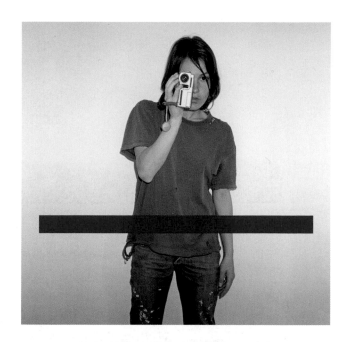

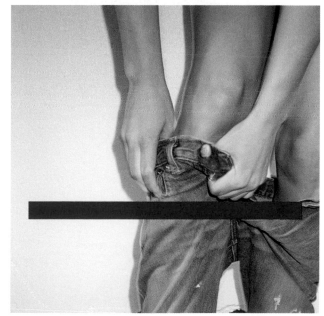

Project
CD artwork
Photography: Jürgen Teller
Design: Howard Wakefield

Title
New Order "Get Ready"

Client
London Records

Year
2001

Pierre di Sciullo

Pierre di Sciullo 12, avenue du Château, 77220 Gretz Armainvilliers, France
T +33 1 64 07 24 32 E atelier@quiresiste.com www.quiresiste.com

"Graphic design: see forms and meanings/ forms: see sign (cf. signification) and de-sign/ design: see graphic. 'I was walking in the forest when suddenly this graphic design totally modified my life'."

"Most of the independent graphic designers will be employed by big agencies to clean the windows. The survivors will be the one's who don't ask silly questions such as 'Is it something else other than business?', 'Why is the world of fashion so empty?', 'Am I only a servant of the enterprise?'. If you take the money and run, no problem. But sometimes it's hard to be a citizen of a rich country – you have misgivings. Your way will be the graphic design of nice sentiments, which I call 'Gradenice': war, poverty, Aids, what a shame ... In the future I hope the use of media will become more efficient again, so the question of the inner value of the work will appear more and more indecent: my work is good because it is visible – of course it is visible because it is good. But to save this situation commissioners will have to study at art and design schools. This next generation will begin making strong, open, intelligent projects and the sun will shine on a pacified world."

» Die meisten freischaffenden Grafiker werden von den großen Agenturen als Fensterputzer beschäftigt. Überleben werden diejenigen, die keine dummen Fragen stellen wie etwa: ›Geht es außer ums Geschäft noch um etwas anderes?‹ – ›Warum ist die Modewelt so leer?‹ – ›Bin ich nur ein Diener des Unternehmens?‹ Wenn man das Geld nimmt und denkt: ›Nach mir die Sintflut‹, ist das in Ordnung. Manchmal aber ist es gar nicht so leicht, Bürger eines reichen Landes zu sein – man ahnt Böses. Der Weg wird das Grafikdesign angenehmer Gefühle sein: Krieg, Armut, Aids, bedauerlich, aber ... In Zukunft, so hoffe ich, wird das Medium wieder wirksamer werden, so dass die Frage nach dem inneren Wert einer Grafik zunehmend als unangebracht gelten wird. Meine Arbeit ist gut, weil sie auffällt – und natürlich fällt sie auf, weil sie gut ist. Die nächste Generation wird starke, offene, intelligente Projekte in Angriff nehmen und die Sonne wird über einer befriedeten Welt aufgehen.»

« La plupart des graphistes indépendants seront engagés dans les grandes agences pour nettoyer les vitres. Les survivants seront ceux qui ne poseront pas de questions bêtes comme : ‹ Y a-t-il autre chose que le commerce ? Pourquoi le monde de la mode est-il si vide ? Suis-je au bout du compte le serviteur des entreprises ? › Prends l'argent et tire-toi, ça ne pose pas de problème. Mais quelquefois c'est dur d'être le citoyen d'un pays riche, on a des états d'âme ; solution : pratiquer le GRABS, le GRAphisme des Bons Sentiments, à propos de la guerre, du Sida, de la pauvreté, quel dommage... L'usage des médias sera encore plus efficace afin que la question de la valeur même d'un travail semble indécente. ‹ Mon travail est bon car il est visible, bien sûr il est visible parce qu'il est formidable en vérité.› Pour sauver la situation les commandataires feront leur apprentissage dans les écoles d'art et de design. Cette nouvelle génération lancera des projets intelligents, forts et ouverts et le soleil brillera sur un monde pacifié. »

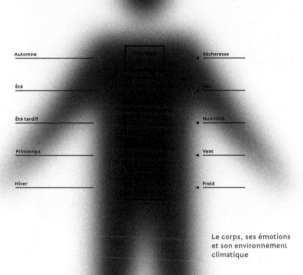

Le corps, ses émotions
et son environnement
climatique

Project
Exhibition "médecines chinoises"

Title
Hierarchy of organs and their
relations with feelings and weath-
er

Client
Grande Halle de la Villette, Paris

Year
2001

Project
Two typefaces designed specially for glass,
easy to cut in this medium

Title
Minimum overlap
Blocs

Client
Self-published

Year
2001

Project
Exhibition "Médecines chinoises"

Title
Médecines chinoises

Client
Grande Halle de la Villette, Paris

Year
2001

Suburbia

Suburbia 74 Rochester Place, London NW1 9JX, UK
T +44 20 7424 0680 F +44 20 7424 0681 E info@suburbia-media.com www.suburbia-media.com

"We are reaching for a perfect synergy of information, image, design and parties."

"We here at Suburbia are inclined to approach the future sideways – laterally if you like. This way we feel less likely to be caught out by it. Thinking about the future in general was enormously popular in pre-revolutionary Russia, but not so much nowadays. Cultural determinants you see are not really dictated by designers, and there are pitfalls in thinking so. The sands, you might say, on which the future rests are always shifting (this is an adaptation or bastardisation of an old Chinese proverb about trusting those who you do business with), which is definitely something we're going to pay more attention to in the future."

» Wir von Suburbia tendieren dazu, uns der Zukunft von der Seite zu nähern. So haben wir das Gefühl, dass sie uns nicht so schnell ertappen kann. Im vorrevolutionären Russland war es äußerst populär, sich Gedanken über die Zukunft im Allgemeinen zu machen, das ist heute nicht mehr so. Kulturelle Determinanten werden nicht wirklich von den Designern diktiert. Das zu glauben, birgt Risiken. Der Sand, auf dem die Zukunft steht, wandert immer weiter (so könnte man in Abwandlung eines alten chinesischen Sprichworts über das Vertrauen zu denen sagen, mit denen man Geschäfte macht) und das ist definitiv etwas, dem wir in Zukunft mehr Aufmerksamkeit widmen werden.«

« Ici à Suburbia, on tend à aborder le futur de biais, latéralement si vous préférez. On espère ainsi limiter le risque d'être pris de court. Dans la Russie d'avant la révolution, réfléchir à l'avenir était une activité très prisée. Ça l'est moins aujourd'hui. Il serait dangereux de croire que les déterminants culturels apparents sont en fait dictés par les créateurs. Les ‹bancs de sable› sur lesquels repose le futur sont aussi mouvants (j'adapte, ou plutôt je détourne, un vieux proverbe chinois parlant de la confiance que l'on peut accorder à ses partenaires en affaire), un aspect auquel nous serons certainement plus attentifs à l'avenir.»

Opposite page:

Project
Magazine cover
Photography by Phil Poynter

Title
Big Magazine – Horror

Client
Big

Year
2000

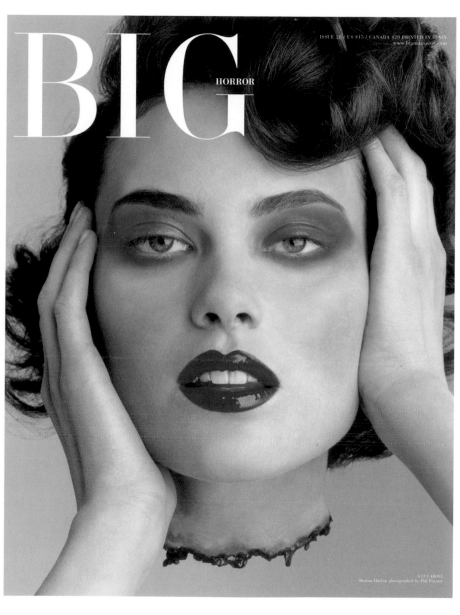

BIG

HORROR

ISSUE 28 / US $15 / CANADA $20 PRINTED IN SPAIN
www.bigmagazine.com

A CUT ABOVE
Shalom Harlow photographed by Phil Poynter

BIG HORROR ISSUE 28

ITALIA LIRE 20000 UK £7.95 ESPANA PTS 1.200 www.bigmagazine.com

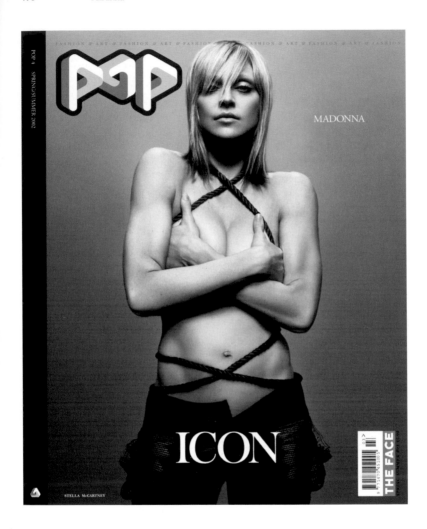

Project
Magazine cover
Photography by Mert Allas and Marcus
Piggot

Title
Pop, issue 4 – Icons

Client
Emap Publishing

Year
2002

Opposite page:

Project
Creative Review anniversary artwork

Title
Infinity Poster

Client
Creative Review

Year
2001

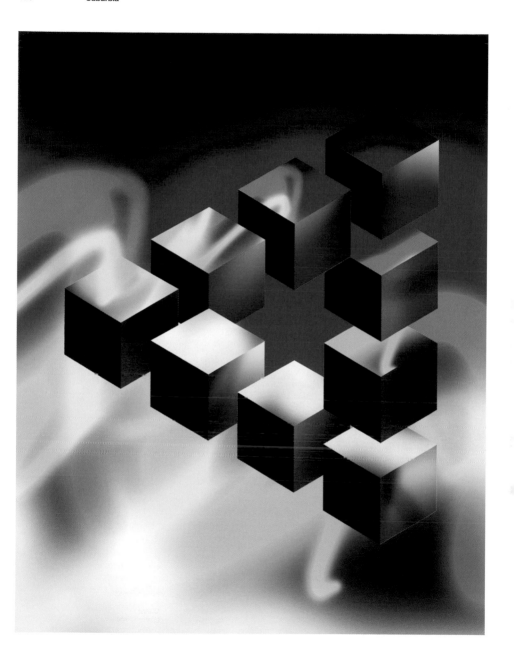

Sweden Graphics

Sweden Graphics Blekingegatan 46, 11664 Stockholm, Sweden
T +46 8 652 0066 F +46 8 652 0033 E hello@swedengraphics.com www.swedengraphics.com

"Not by making interesting graphic design but by making graphic design interesting"

"After all these years of dedicated work and the problems with embracing new media and technology, graphic design is finally starting to achieve what it really needed all along – an audience. Graphic design has always been a kind of sidekick to almost every other kind of cultural platform such as literature, film, art, advertising, music etc – sometimes appreciated but often neglected. At times debated, but only within the design community itself. But in the last ten years or so a massive interest has started to grow among the younger generation in graphic design as an end in itself. It is our guess that it is mainly through the process of making their own web sites that young people of today automatically gain a hands-on knowledge of typefaces, colour and composition, and that these insights make them more capable and interested in seeking out, evaluating and at best appreciating the work of more professional designers. This is the single most important factor which, in the foreseeable future, will turn graphic design into a means of expression in itself, and more so than ever before. A language that is powerful not only because there are competent speakers but because there are competent listeners. Thank you for your attention."

» Nach all den Jahren Arbeit und Schwierigkeiten mit den neuen Medien und ihrer Technik beginnt die Grafikdesignbranche endlich das zu erreichen, was sie die ganze Zeit über schon gebraucht hätte – ein Publikum. Die Gebrauchsgrafik hat andere Kulturbereiche wie Literatur, Film, Kunst, Werbung, Musik usw. immer begleitet und wurde dabei manchmal geschätzt, oft aber vernachlässigt. Mitunter umstritten, aber nur innerhalb der Grafikerzunft selbst. In den letzten zehn Jahren ist jedoch das Interesse am Grafikdesign an sich gestiegen, besonders unter jüngeren Leuten. Sie haben mit ihren eigenen Internetportalen den praktischen Umgang mit Schriftarten, Farben und Bildkomposition geübt, so dass sie sich nun auch für die Arbeiten professioneller Grafiker interessieren, sie bewerten und – im günstigsten Fall – schätzen lernen. Das ist der wichtigste Faktor, der in naher Zukunft aus dem Grafikdesign ein eigenständiges Ausdrucksmedium machen wird, eine Sprache, die nicht nur deshalb wirkungsvoll ist, weil sie von kompetenten Interpreten benutzt wird, sondern weil sie von kompetenten Zuhörern aufgenommen wird. Vielen Dank für Ihre Aufmerksamkeit.«

«Après toutes ces années de travail acharné et de problèmes pour s'adapter aux nouveaux moyens de communication et à la technologie, le graphisme commence enfin à obtenir ce dont il avait vraiment besoin : un public. Il a toujours été une sorte de parent pauvre de presque toutes les autres plates-formes culturelles telles que la littérature, le cinéma, l'art, la publicité, la musique, etc., parfois apprécié mais le plus souvent négligé. Si on en débattait, cela ne sortait pas de la communauté des créateurs. Toutefois, ces dix dernières années, on a observé un intérêt massif de la nouvelle génération pour le graphisme en tant que tel. C'est probablement en réalisant leurs propres pages web que les jeunes ont acquis sur le tas une connaissance des types de caractères, des couleurs et de la composition. Cela les a incités à rechercher, à évaluer et, au mieux, à apprécier le travail de graphistes plus professionnels. C'est sans doute le principal facteur qui, dans un futur proche, transformera le graphisme en un moyen d'expression à part entière. Un langage qui puise sa force non seulement dans la compétence de ceux qui le parlent mais également dans celle de ceux qui l'écoutent. Merci de votre attention. »

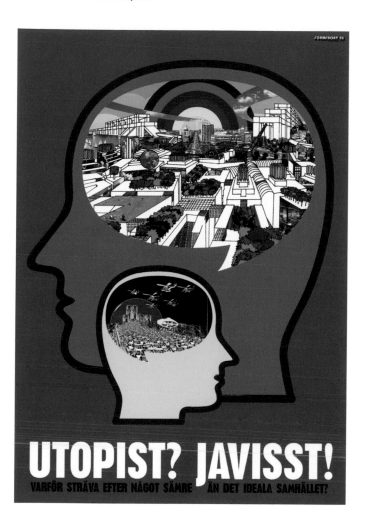

Project
Poster

Title
Utopist – Javisst

Client
Formfront

Year
1998

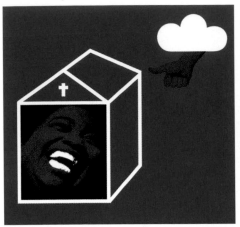

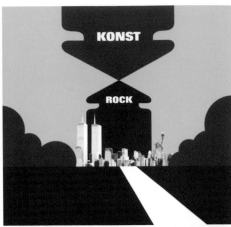

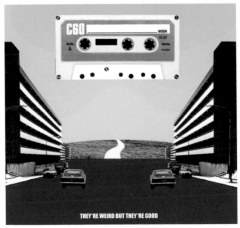

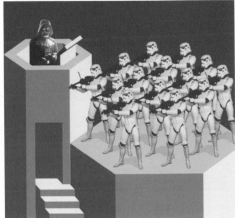

Project
Newspaper illustrations for music review
pages

Title
Newspaper illustrations for music review
pages

Client
DN På Stan

Year
1999–2001

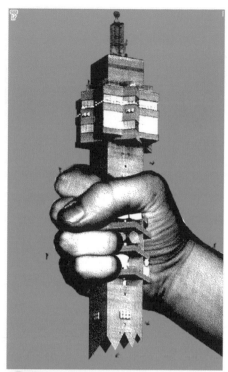

Skala 1:1

En improviserad helaftonsföreställning. Premiär 18 februari

Improvisationsformen i Skala 1:1 är inspirerad av den San Franciscobaserade improvisations-
gruppen True Fiction Magazine. Små bitar av historier läggs samman till längre berättelser. Dessa
bildar en helhet I full skala som pendlar mellan tid och rum, logik och fantasi, komedi och tragedi.
Regina Saisi från True Fiction Magazine inledde med en tre veckor lång workshop varefter Roger
Westberg tng river och slutförde repetitionsarbetet. Detta är grunden till en mer fördjupad och
variationsrik improvisationsform där publiken lovas en ny händelserik föreställning varje kväll.

 | **Stockholms Improvisationsteater** | Biljetter och information
Torsdag–Lördag kl.19.00 Sigtunagatan 12, T-Odenplan | **08-30 62 42**
www.impro.a.se

Skala 1:1

En improviserad helaftonsföreställning. Premiär 16 Februari

Med en berättarteknik, lik den i Robert Altmans film "Short Cuts", framförs korta sekvenser av historier som läggs samman
till längre berättelser. Dessa bilder en helhet i full skala som pendlar mellan tid och rum, logik och fantasi, komedi och tragedi.
I varje föreställning skapas helt nya historier och berättelser, karaktärer och öden – vilket gör varje kväll till en premiär.

| **Stockholms Improvisationsteater** | Biljetter och information
Fredag–Lördag kl.19.00 Sigtunagatan 12, T-S:t Eriksplan | **08-30 62 42**
www.impro.a.se

Project
Flyers

Title
Skala 1:1

Client
Stockholms Improvisationsteater

Year
2000

Andrea Tinnes DASDECK, Schliemansstrasse 6, 10437 Berlin, Germany
T +49 30 61 60 95 54 F +49 30 44 03 16 29 E andrea@dasdeck.de www.wander-lust.de

"With a passion for visual eloquence I try to establish my own place between commerce and art."

"While reflecting on the themes and schemes within graphic design over the last decade the hype of the information superhighway, blind enthusiasm for hardware and software, a bigger is better attitude, the demise of the cutting edge, the chase after the next new thing, the dawn of Helvetica Neo-Modernism, the vector vs. bitmap battles, the buzz about branding, the self-indulgent identity crisis of graphic design – I find myself with a paradoxical and rather romantic vision of the graphic design of the future: a return to graphic design's classical virtues: a return to original ideas, to creative imagination, to skilled craftmanship, to idiosyncratic aesthetics, to political awareness, to social responsibility and to critical attitudes."

» Wenn ich über all die Themen und Programme innerhalb der Grafikdesign-Debatten der letzten Jahre nachdenke – den enormen ›Hype‹ um den ›Information Superhighway‹, den blinden Enthusiasmus für Hard- und Software, den ganzen ›größer, besser, schneller‹-Wahnsinn, den ruhmlosen Niedergang des ›Cutting Edge‹, die unterbrochene Jagd nach dem nächsten letzten Schrei, das Aufkeimen einer neuen Helvetica-Moderne, die Vector-versus-Bitmap-Schlachten, die übersteigerte Aufregung um den Begriff des ›Brandings‹, die selbst gestrickte Identitätskrise des Grafikdesigns – dann stelle ich paradoxerweise fest, dass meine Vision eines zukünftigen Grafikdesigns ziemlich romantisch anmutet; nämlich eine einfache Rückbesinnung auf seine klassischen Tugenden: intelligente Ideen, kühne Fantasien, ungewohnte Ästhetik, handwerkliches Können, politisches Bewusstsein sowie soziale Verantwortlichkeit.«

« Quand je réfléchis aux thèmes et schémas de la création graphique des dix dernières années, au battage médiatique sur la super autoroute de l'information, à l'enthousiasme aveugle pour le matériel informatique et les logiciels, à l'attitude ‹plus c'est grand, mieux c'est›, à la disparition de l'avantgarde, à la course après la nouveauté, à l'avènement du ‹Néomodernisme Helvetica›, aux combats du vectoriel contre le matriciel, au tintouin autour du ‹branding›, à la crise d'identité complaisante du graphiste, je me rends compte que j'ai une vision paradoxale et plutôt romantique de l'avenir de ma profession : un retour aux vertus classiques, aux idées originales, à l'imagination créative, au savoir-faire artisanal, aux esthétiques individuelles, à la conscience politique, à la responsabilité sociale et aux attitudes critiques.»

Project
Poster announcing the German filmfestival
in Georgia (Eastern Europe)

Title
Tage des deutschen Films in Tbilissi

Client
Medea:
Film/Production/Service

Year
2002

Project
Font / Interface / http://volvox.dasdeck.com

Title
Volvox

Client
Self-published /
Martin Perlbach

Year
1999/2002

Project
Poster displaying the typeface "Stitch-me"

Title
Stitch-Me

Client
Self-published

Year
2001

Tycoon Graphics

Tycoon Graphics 402 Villa Gloria, 2–31–7 Jingumae, Shibuya-ku, Tokyo 150–0001, Japan
T +81 3 5411 5341 F +81 3 5411 5342 E mail@tyg.co.jp

"Like using a Time-Machine. Leap into the consciousness of the future then bring it back to the present, and design."

"The importance of graphic design as a language will be raised more than ever in the future. Yet on the other hand, as the global trend of youth becomes increasingly sensuous, graphic design will be used as a sensory medium which cannot be described as a verbal language, or as an entertainment tool. As such, the role of graphic design will become more important as a cultural medium and graphic designers will find themselves in high demand."

» Die Bedeutung des Grafikdesigns als Kommunikationssprache wird künftig noch zunehmen. Andererseits wird die Gebrauchsgrafik in dem Maße, in dem Jugendliche in aller Welt zu sinnlicheren Ausdrucksformen tendieren, zum Werkzeug dieser Entwicklung, die sich mit Sprache nicht ausdrücken lässt. Oder aber sie wird zum Instrument der Unterhaltung. Dadurch wird die Gebrauchsgrafik als Kulturmedium an Bedeutung gewinnen und Grafiker werden sehr gefragt sein.«

« A l'avenir, le graphisme en tant que langage prendra encore plus d'importance. Parallèlement, à mesure que la tendance mondiale en faveur de la jeunesse se fera de plus en plus sensuelle, le graphisme servira d'outil pour décrire ce qui ne peut l'être verbalement, ou comme un instrument de divertissement. A ce titre, son rôle de moyen de communication culturel se renforcera encore et les graphistes seront très demandés. »

Opposite page:

Project
Poster

Title
Atehaca

Client
Toshiba Corporation

Year
2001

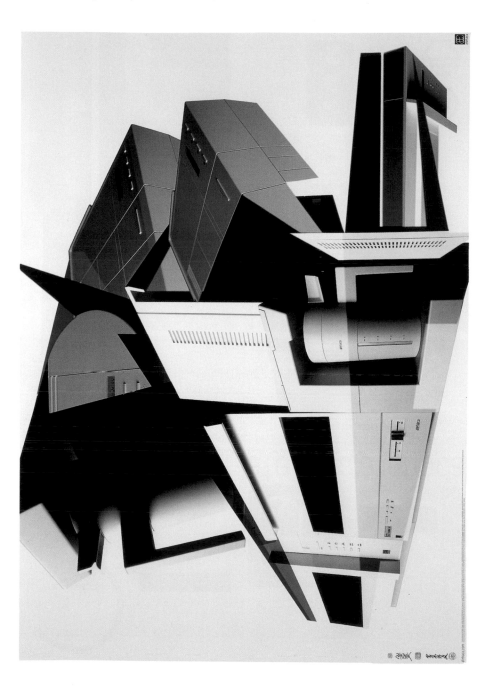

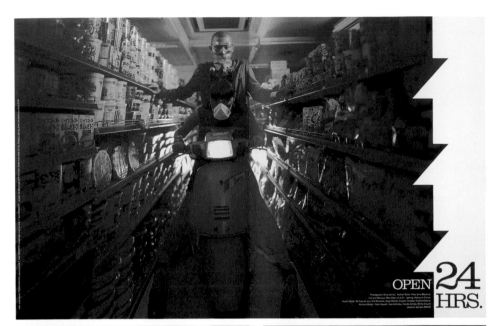

OPEN **24** HRS.

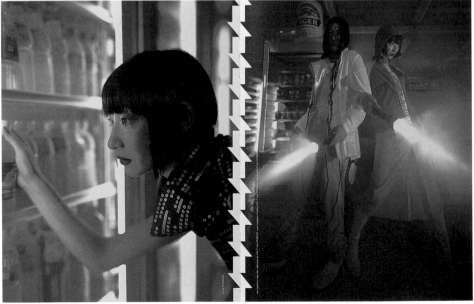

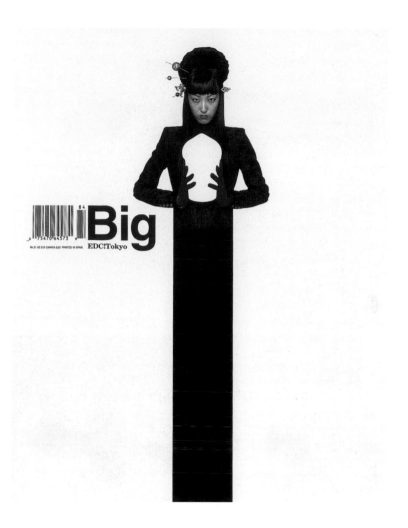

Project
Big Magazine spreads and cover

Title
Big EDC! Tokyo Issue

Client
Big Magazine

Year
1998

Gunnar Thor Vilhjalmsson

Gunnar Thor Vilhjalmsson, Fagrihjalli 26, 200 Kopavogur, Iceland
T +35 4 823 2884 E gunnar@deluxe.is www.deluxe.is

"Relax and enjoy the ride."

"The future of graphic design will be minimal – not so minimal – definitely not minimal – total chaos. Followed by definitely not minimal – not so minimal – minimal – not so minimal – definitely not minimal – total chaos – ∞"

» Die Zukunft des Grafikdesigns ist minimales – nicht so minimales – definitiv nicht minimales – totales Chaos. Gefolgt von definitiv nicht minimalem – nicht so minimalem – minimalem – nicht so minimalem – definitiv nicht minimalem – totalem Chaos – ∞«

« L'avenir de la création graphique sera minimal – pas si minimal – pas minimal du tout – un chaos total. Suivi par pas du tout minimal – pas si minimal que ça – minimal – pas si minimal que ça – pas du tout minimal – un chaos total – ∞ »

Opposite page:

Project
Schedule for Sirkus

Title
Boy

Client
Sirkus

Year
2000

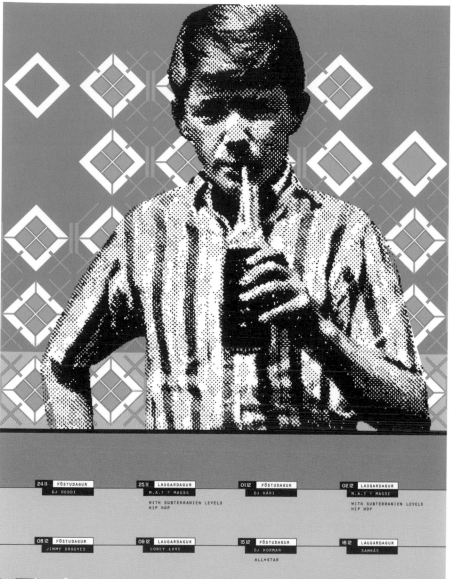

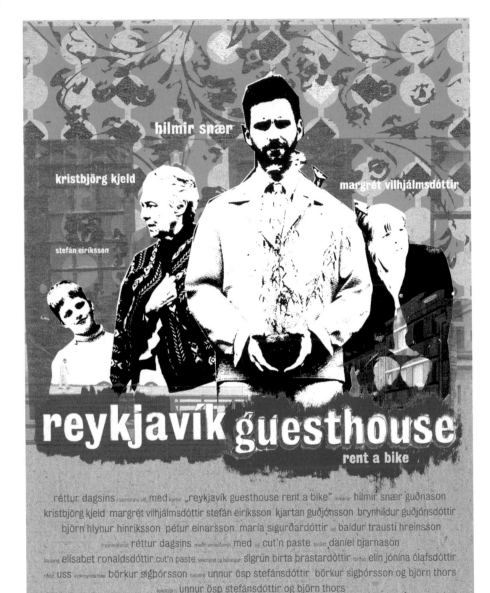

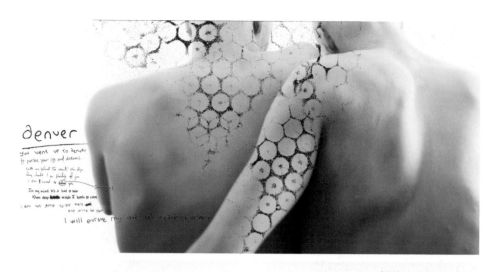

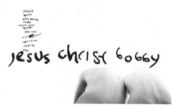

Opposite page:

Project
Poster for the film "Reykjavik Guesthouse –
Rent a Bike"

Title
Reykjavik Guesthouse

Client
Rettur Dagsins

Year
2001

Project
CD cover for the hardcore punkrock band
Minus

Title
Jesus Christ Bobby

Client
Minus – Smekkleysa

Year
2000

Why Not Associates

Why Not Associates 22C Shepherdess Walk, London N1 7LB, UK
T +44 207 253 2244 F +44 207 253 2299 E info@whynotassociates.com www.whynotassociates.com

"Trying to enjoy it as much as possible, while getting paid."

"God only knows" » Gott allein weiß es« « Dieu seul le sait »

Opposite page:

Project
Exhibition poster

Title
Malcolm McLaren's Casino of Authenticity
and Karaoke

Client
Malcolm McLaren

Year
2001

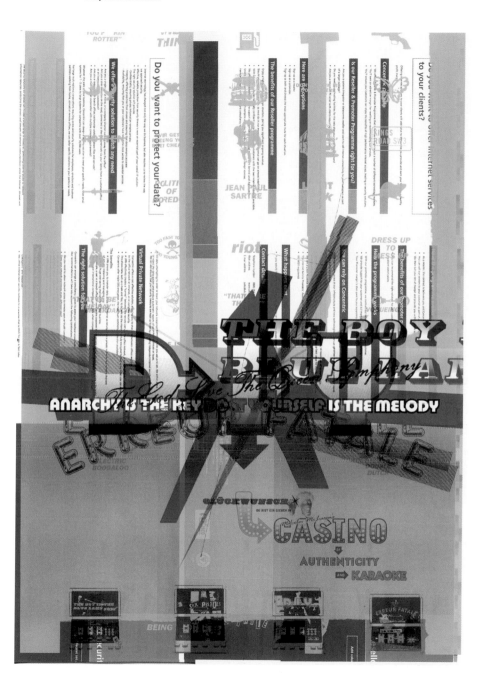

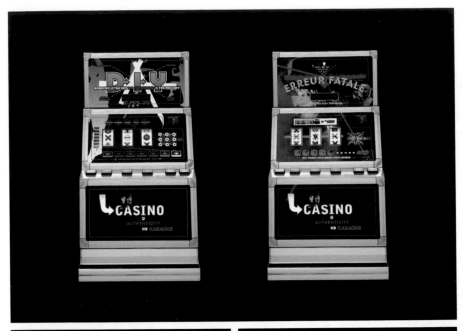

Project
Exhibition installation & T-shirt design

Title
Malcolm McLaren's Casino of Authenticity
and Karaoke

Client
Malcolm McLaren

Year
2001

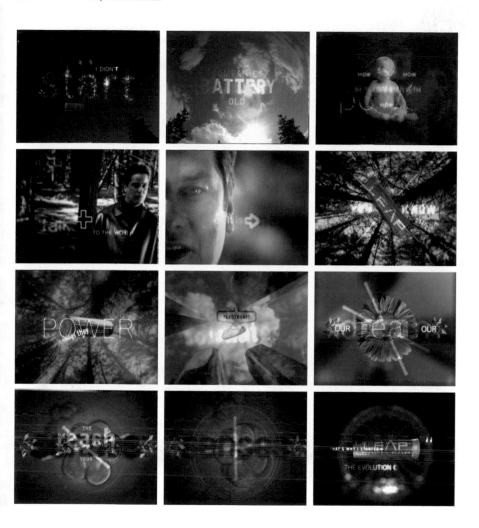

Project
Television commercial

Title
Forest

Client
Leap Batteries

Year
2001

Design Handbook.
Eds. Charlotte & Peter Fiell /
Flexi-cover, 192 pp. / € 6.99 /
$ 9.99 / £ 5.99 / ¥ 1.500

Design of the 20ᵗʰ Century
Eds. Charlotte & Peter Fiell /
Flexi-cover, 192 pp. / € 6.99 /
$ 9.99 / £ 5.99 / ¥ 1.500

Design of the 21ᵗʰ Century
Eds. Charlotte & Peter Fiell /
Flexi-cover, 192 pp. / € 6.99 /
$ 9.99 / £ 5.99 / ¥ 1.500

"These books are beautiful objects, well-designed and lucid." —*Le Monde*, Paris, on the ICONS series

"Buy them all and add some pleasure to your life."

60s Fashion
Ed. Jim Heimann

70s Fashion
Ed. Jim Heimann

African Style
Ed. Angelika Taschen

Alchemy & Mysticism
Alexander Roob

American Indian
Dr. Sonja Schierle

Angels
Gilles Néret

Architecture Now!
Ed. Philip Jodidio

Art Now
Eds. Burkhard Riemschneider,
Uta Grosenick

Atget's Paris
Ed. Hans Christian Adam

Bamboo Style
Ed. Angelika Taschen

Ingrid Bergman
Ed. Paul Duncan, Scott Eyman

Berlin Style
Ed. Angelika Taschen

Humphrey Bogart
Ed. Paul Duncan, James Ursini

Marlon Brando
Ed. Paul Duncan,
F.X. Feeney

Brussels Style
Ed. Angelika Taschen

Cars of the 50s
Ed. Jim Heimann,
Tony Thacker

Cars of the 60s
Ed. Jim Heimann, Tony Thacker

Cars of the 70s
Ed. Jim Heimann, Tony Thacker

Charlie Chaplin
Ed. Paul Duncan, David Robinson

China Style
Ed. Angelika Taschen

Christmas
Ed. Jim Heimann, Steven Heller

Design Handbook
Charlotte & Peter Fiell

Design for the 21ˢᵗ Century
Eds. Charlotte & Peter Fiell

Design of the 20ᵗʰ Century
Eds. Charlotte & Peter Fiell

Marlene Dietrich
Ed. Paul Duncan,
James Ursini

Devils
Gilles Néret

Robert Doisneau
Ed. Jean-Claude Gautrand

East German Design
Ralf Ulrich/Photos: Ernst Hedler

Clint Eastwood
Ed. Paul Duncan, Douglas
Keesey

Egypt Style
Ed. Angelika Taschen

Encyclopaedia Anatomica
Ed. Museo La Specola Florence

M.C. Escher

Fashion
Ed. The Kyoto Costume Institute

Fashion Now!
Eds. Terry Jones, Susie Rushton

Fruit
Ed. George Brookshaw,
Uta Pellgrü-Gagel

HR Giger
HR Giger

Grand Tour
Harry Seidler

Cary Grant
Ed. Paul Duncan, F.X. Feeney

Graphic Design
Eds. Charlotte & Peter Fiell

Greece Style
Ed. Angelika Taschen

Halloween
Ed. Jim Heimann,
Steven Heller

Havana Style
Ed. Angelika Taschen

Audrey Hepburn
Ed. Paul Duncan, F.X. Feeney

Katharine Hepburn
Ed. Paul Duncan, Alain Silver

Homo Art
Gilles Néret

Hot Rods
Ed. Coco Shinomiya, Tony
Thacker

Hula
Ed. Jim Heimann

India Bazaar
Samantha Harrison, Bari Kumar

London Style
Ed. Angelika Taschen

Steve McQueen
Ed. Paul Duncan, Alain Silver

Mexico Style
Ed. Angelika Taschen

Miami Style
Ed. Angelika Taschen

Minimal Style
Ed. Angelika Taschen

Marilyn Monroe
Ed. Paul Duncan,
F.X. Feeney

Morocco Style
Ed. Angelika Taschen

New York Style
Ed. Angelika Taschen

Paris Style
Ed. Angelika Taschen

Penguin
Frans Lanting

20ᵗʰ Century Photography
Museum Ludwig Cologne

Pierre et Gilles
Eric Troncy

Provence Style
Ed. Angelika Taschen

Robots & Spaceships
Ed. Teruhisa Kitahara

Safari Style
Ed. Angelika Taschen

Seaside Style
Ed. Angelika Taschen

Signs
Ed. Julius Wiedeman

South African Style
Ed. Angelika Taschen

Starck
Philippe Starck

Surfing
Ed. Jim Heimann

Sweden Style
Ed. Angelika Taschen

Tattoos
Ed. Henk Schiffmacher

Tiffany
Jacob Baal-Teshuva

Tokyo Style
Ed. Angelika Taschen

Tuscany Style
Ed. Angelika Taschen

Valentines
Ed. Jim Heimann,
Steven Heller

Web Design: Best Studios
Ed. Julius Wiedemann

Web Design: Best Studios 2
Ed. Julius Wiedemann

Web Design: E-Commerce
Ed. Julius Wiedemann

Web Design: Flash Sites
Ed. Julius Wiedemann

Web Design: Music Sites
Ed. Julius Wiedemann

Web Design: Portfolios
Ed. Julius Wiedemann

Orson Welles
Ed. Paul Duncan,
F.X. Feeney

**Women Artists
in the 20th and 21st Century**
Ed. Uta Grosenick